Film Actors
Volume 19
ERROL FLYNN
Documentary study

Part 1

ISBN-13 : 978-1512396232
ISBN-10 : 1512396230
Copyright©2012-2014 Iacob Adrian
All Rights Reserved.

Notice

This documentary study use historic, archived documents.

Because of this, some pages may look blurry or low quality.

Still are included in this book because they have

high value from critical, documentary, historical,

informative and journalistic point of view .

Dtp and graphic design

Iacob Adrian

**Copyright©2012-2014 Iacob Adrian
All Rights Reserved.**

Author statement

The actors and actresses are the the bricks .

The cast and crew are the plaster .

They stand on the foundation created by producers and writers and directors .

All these people creates the great palace of the art of film .

Iacob Adrian - 2013

This little Book conveys the greetings of

..

to

..

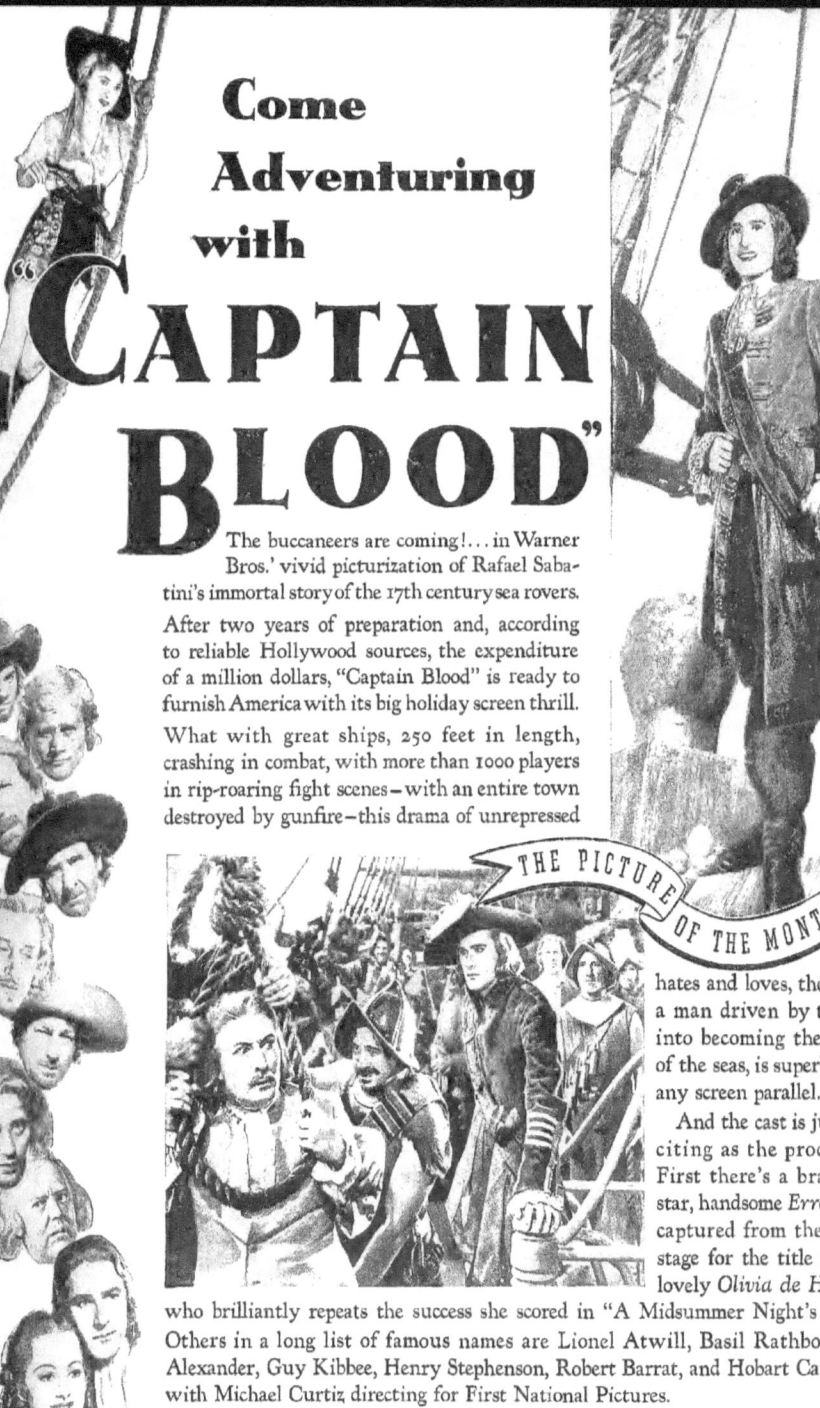

Come Adventuring with "CAPTAIN BLOOD"

The buccaneers are coming!... in Warner Bros.' vivid picturization of Rafael Sabatini's immortal story of the 17th century sea rovers.

After two years of preparation and, according to reliable Hollywood sources, the expenditure of a million dollars, "Captain Blood" is ready to furnish America with its big holiday screen thrill.

What with great ships, 250 feet in length, crashing in combat, with more than 1000 players in rip-roaring fight scenes – with an entire town destroyed by gunfire – this drama of unrepressed hates and loves, the story of a man driven by treachery into becoming the scourge of the seas, is superb beyond any screen parallel.

And the cast is just as exciting as the production! First there's a brand-new star, handsome *Errol Flynn*, captured from the London stage for the title role; and lovely *Olivia de Havilland* who brilliantly repeats the success she scored in "A Midsummer Night's Dream". Others in a long list of famous names are Lionel Atwill, Basil Rathbone, Ross Alexander, Guy Kibbee, Henry Stephenson, Robert Barrat, and Hobart Cavanaugh, with Michael Curtiz directing for First National Pictures.

To do justice with words to the fascination of "Captain Blood" is impossible. See it! It's easily the month's grandest entertainment. And Warner Bros. deserve our thanks for so brilliantly bringing alive a great epoch and a great story!

THE PICTURE OF THE MONTH

Errol Flynn's Unofficial Sweetheart

Olivia de Havilland's success in *Captain Blood* gave her the leading rôle in *Charge of the Light Brigade*, Errol Flynn's second picture

Errol Flynn, dashing star of *Captain Blood*, has an unofficial on-the-screen-only sweetheart, one who meets the approval of his lovely wife, Lili Damita, and the world at large.

Perhaps, if you saw Olivia de Havilland in the pirate picture, you share with us the desire to find these two new and exciting personalities in more films together. And we're going to get our wish!

Olivia, petite and big-eyed, is Errol's leading lady in *Charge of the Light Brigade*. Warner Brothers are just completing the picture now. And here's news! Warners soon will go into production on *The White Rajah*, and again Olivia is scheduled to play opposite Errol Flynn. It is interesting to note here that *The White Rajah* is a story conceived by Flynn during his own adventures in the Far East. It is co-authored by the star in collaboration with William Ulman, Jr., whose stories you have often read in Hollywood Magazine.

But back to Olivia, whose own story deserves full mention. We were kidding with her about this screen romance with Errol, and she flipped back like this:

"I won't marry an actor because most of them are impractical."

We suggested that Errol was practical enough.

"He's practical, all right," she admitted, "but he's married, you know. To Lili Damita. And she's awfully nice. We're good friends. She often comes on the set when we are playing together in pictures. No, Errol's not exactly the type. And besides, if he were—and he weren't married—it still wouldn't mean a thing.

"I am a little in awe of him, incidentally. Why, when we finished *Captain Blood* he really astonished me when he said he would like to have me play a romantic lead with him again in his next picture. I had thought he was just sort of putting up with me. So, you see, we may be screen sweethearts, but I don't really know him very well. He's hard to know. He surprised me again by asking for me in *The White Rajah*. That ought to be a lot of fun to make. I hope we start it soon."

Lightning In Her Life

● A Year Ago Olivia de Havilland lived a quiet, peaceful life of total unsophistication in the small California town of Saratoga; today she is still living the same sort of way, excepting that she is one of the most talented, beautiful and successful young actresses in all Hollywood.

That's a lot of change for one brief year, yet it has not affected our pretty home town girl in the slightest. It is a fortunate thing, for whether Olivia realizes it or not, her phenomenal success is due in part, at least, to the fact that she has the naiveté of an unspoiled child.

Olivia, standing here before us with sparkling, large brown eyes, finds it a little difficult to believe her own success story.

"It all happened so suddenly and unexpectedly," she explained to us, dimpling into a smile. "Why, I have been in Hollywood a little more than a year now, yet it seems only yesterday that I was back in Saratoga reciting a little Shakespeare when mother would see fit. Things occurred so fast after that. It is difficult to diagnose what happened, but no small part of my picture is filled with emotional *fear*."

People who know Hollywood can understand how a young actress can be frightened nigh out of her wits at the thought of facing a camera, but unless you have worked under the lightning touch of Max Reinhardt, you have never known what it is to be really uneasy before the camera.

Child Of The Far East

● Reinhardt Is The transition point in Olivia's otherwise smooth-flowing life. Although she was born in Tokio, Japan, where her father was practicing law, that period of her life means little to the actress. Her parents brought her to California when she was three years old. And amid the 800-odd occupants of little Saratoga, Olivia grew up into the lovely lady you have met on the screen.

Her mother, an accomplished elocutionist, later became a professional reader specializing on Shakespearean plays. Gradually her mother allowed her to read small rôles, then better ones. Last year Olivia won a scholarship to Mills College and on the brink of matriculating, met Max Reinhardt through a friend.

At this point lightning entered her life. The chain of events went flashing around. And Olivia's memory of succeeding weeks is one punctuated mostly with fear and trembling and no small

Errol Flynn's Unofficial Sweetheart

amount of delight. Reinhardt engaged her to understudy the rôle of Hermia for his Hollywood Bowl production of *Midsummer Night's Dream*. Her work was so excellent that she not only played the Bowl engagement, but went on the road with the show for eight weeks. To this very day she marvels that Reinhardt chose her for the film rôle when he undertook *The Dream* for Warner Brothers.

"The maestro's reputation is enough to frighten anyone," Olivia confesses with charming frankness. "And my own inexperience could hardly be helpful. I was literally frightened out of a year's growth. I would go on the set and pray—really *pray*—that I wouldn't be called on to act that day. Perhaps it would have been easier had I understood Mr. Reinhardt's own language. His English was too broken to be always clear. Yet on the other hand, Mr. Dieterle (Max's assistant director who has since made smash hits of his own for Warners) spoke better English, and I was afraid of him because he did. These two men knew so much, ordered their players around with such assurance. Why, even the old timers like James Cagney and Joe E. Brown and Dick Powell were uncertain and nervous. Do you wonder that my mind was a great tangle of *fear*?"

Her Modest Apartment Home

● OLIVIA LIVES WITH her mother and sister in a modest—according to the Hollywood view—apartment on Franklin Avenue just above Hollywood Boulevard.

When she first came down from tiny Saratoga, her mother couldn't make the trip with her. It was Olivia's first trip alone, and it took all the courage of her eighteen years to face the city of films. But despite her constant fears, she immersed herself in her work and found life entirely satisfactory.

After the strain of *The Dream* was over, Olivia found pleasant respite in doing *Alibi Ike* with Joe E. Brown. After that came *The Irish in Us* with Jimmy Cagney and Pat O'Brien. Both of these would be coveted rôles for most beginners, but they were nothing in comparison to the breaks yet to come.

Warners discovered Flynn and starred him in *Captain Blood*. Olivia was given the feminine lead, and shared honors as equally as any woman could in a distinctly man's picture. We have seen her in *Anthony Adverse* with Fredric March. Again it seemed like awfully "big-time" stuff to the new little actress, but instead of the old fear, she found this perhaps the most pleasant picture yet. We have seen the preview of *Adverse*; her acting is right up alongside March's title rôle.

Olivia does not like to attend previews. When she sees herself on the screen, her characterizations seem cold and stilted to her. The strain of listening for audience reactions takes whatever pleasure there is left in the picture. So she prefers to wait until the picture has reached the second run theaters before she sees herself as others see her.

Night Life In Filmland

● HOLLYWOOD ITSELF MEANS very little to her. Olivia has gone occasionally to the Trocadero, the Grove, and other night spots. Seldom with the same escort, though. And these excursions are note-

Romance and grim battle vie for interest in *Charge of the Light Brigade*. There is little doubt that Errol Flynn, in this scene with Olivia de Havilland, is more lover than trooper!

worthy only because of their infrequency.

"I'm too busy," Olivia explains with a twinkle. "Only between pictures do I have much time to myself, and then I prefer to devote it to my family. We're hoping right now to vacation a bit up in British Columbia. It's beautiful up there this time of year, isn't it? I would like to travel over the United States all on one grand tour, but really, I can't afford it."

You may take this with a large grain of salt. Olivia's obvious possibilities at the box office have just won her a new seven-year contract replacing an older and less satisfactory agreement. Currently she earns $600 per week. The studio should soon find it worthwhile to pay her a $2,500 top weekly salary.

Olivia, being nobody's fool, is building up a rainy day reserve. She looks upon the future with caution, has no desire to spend recklessly. With but little spare time, she goes few places and has no really close Hollywood friends although she has many nice acquaintances.

When she isn't working she spends most of her time at home. She swims a little, walks a little, but is not particularly interested in sports. Her natural beauty does not require a great deal of "fixing up" time. Her complexion is naturally rosy, her hair a naturally reddish-brown.

Olivia has no ideas of matrimony now—not even the faintest prospects. But she is interested in men, and one of these times she expects her Prince Charming-lucky fellow!—to come along in a Duesenberg or flivver and sweep her heart away.

There was something of a twinkle in her eye as she said:

"I like men who are both poetical and practical. I want them to be romantic but sensible, and they should do all the talking.

"I've been in love," she said. "I was in love when I was sixteen."

"But you didn't get married?"

"No, he went away. A long time passed, and one day he came back. But he was wearing a bow tie and had hair that was short. Short and sticking up. I don't like men who have bow ties and

Olivia de Havilland as she appears in *Anthony Adverse*, Warner Brothers pictures

crew hair cuts. And he wore black shoes with a brown suit. I wish men wouldn't do that."

Her eyes—and ours—went to our own brown suit. Sighs of relief—we had on white shoes!

It has been something of a secret, but Olivia occasionally writes poetry. You won't find out from her whether it is good or bad, because poetry satisfies a mood and isn't for public consumption in her way of thinking.

"I feel sort of undressed when anyone reads my poetry," she confesses with a hint of a blush. The attitude is a reflection of her innate modesty which creeps out on many an occasion.

Lest anyone conceive of this beautiful young lady as a hothouse flower, we might explain that no scene or situation in a film script is too arduous for Olivia.

During the shooting of *Charge of the Light Brigade* she had many difficult situations. On one occasion Errol Flynn's flashing blade glanced off his antagonist's shoulders and struck her broadly across the face. Momentarily stunned, Olivia took an unexpected dive into an adjoining lake and was fished out by hero Flynn. Events proceeded as if nothing had happened!

Olivia is still so close to being a film go-er rather than a star that she still has hero-worshipping tendencies of old. Margaret Sullavan and Katharine Hepburn are two of her feminine ideals. While we were talking to her Clark Gable, on loan to Warners, stepped into the Green Room where we were lunching.

"He's handsome without his moustache, isn't he?" she whispered. "Is he as stout as he looks?"

"Two hundred pounds of solid muscle," we affirmed.

"Goodness! You know, visiting stars fill me with awe. If they're from our own lot, I have gotten accustomed to them. But men like Gable—"

She left her sentence unfinished. Dick Powell was approaching the table for a moment's conversation. They talked like a couple of kids from the same home town, but what they said had nothing to do with this interview, and we soon walked out the door together, Dick bound for his sound stage, Olivia heading for home, and we to our typewriter.

Why Errol Flynn is Fleeing Hollywood

To SOME MORTAL souls on this earth the call of the South Sea islands is greater than any other thing in the world. To them the *Song of the Islands* is more than a beautiful tune, a romantic interlude. It is a call to adventure in unknown places, an urge to move restless feet toward the mystery of antiquity, a willingness to dare uncharted reefs for the beckoning things beyond.

Errol Flynn is one of these souls, forever restless, forever in the pursuit of adventure. For him there is no glamour in the present, not even in glamorous Hollywood. The restless, haunting look you see in his eyes is not from clever acting. The Errol Flynn of the screen is Errol himself, a man of the far horizons who refuses to linger long in one place. And lately he has heard the call of distant lands.

Errol was just completing work on *Another Dawn* for Warner Brothers when we talked with him about the mysteries of Tahiti, and other islands so remote that they remain nameless to this day.

"I guess the South Seas would lure most anyone," he told us, pacing up and down the sound stage floor as the cameraman worked for new shooting angles. "I don't think I'm much different from anyone else. We'd all go down there if we could. I guess the only difference is that I *am* going just as soon as I wind up this picture."

And there the difference is, as plain a fact as you could ask for. The lure of big money as a dashing movie star, the adulation of fans all over the world, the peacefulness of serene security—these things mean nothing at all to Errol Flynn.

You doubt that?

Then consider the facts. Errol has been in pictures only a brief year. He was "discovered" while the studio was testing for the lead in *Captain Blood*. It needed a dashing young man full of the spirit of adventure. Fate gave Errol that particular screen test, and overnight he became one of Warner's most triumphant personalities.

The studio knew its man all too well. It

In *Charge of the Light Brigade* Errol Flynn plays another dashing, adventurous rôle. Finished with this and two other pictures, Flynn is deserting Hollywood. Read why in this article!

Years of adventure in the South Seas made Errol Flynn a husky, stalwart adventurer. He'll stack up nicely with Atlas anytime!

deciphered that faraway look in Flynn's eyes and sent out an order that might well have read like this:

"Attention all producers: we have a marvelous hit in Errol Flynn. But he is a natural born adventurer who is hard to hold in one spot. Maybe we can keep him inside Hollywood for a year, but not much longer. Do things fast with him."

Of course they didn't send out that exact order. But it is a fact that Errol, in that brief year, completed not only his first picture, but leads in the following masterpieces: *Charge of the Light Brigade*, *Another Dawn* and *Green Light*.

All of these pictures are top notch productions. Most stars would consider it good fortune to do only one of these in a year. With the exception of *Green Light*, all of the films are costume pictures. And in *Green Light* Errol plays the rôle of a doctor who flees misfortune, battles

spotted fever amid the backwoods roughness of Montana. So you see he is fundamentally the adventurous type of man in all three films.

Captain Blood made such a hit that they ran it many months longer than usual. *Charge of the Light Brigade*'s release was held up for that reason. Last month we previewed the latter picture. It will make your masculine or feminine heart pound. Adventure is here in copious quantities, and romance too. It is another tremendous Errol Flynn hit. Soon you will be raving about the picture, and it seems destined for as long a run as *Captain Blood*.

That means only one thing: it will be many months before both *Another Dawn* and *Green Light* are released to the theaters, and it is during these months that Errol will venture into the South Seas to

Why Errol Flynn is Fleeing

Here's Errol Flynn in a scene from *Green Light*, due for spring release. The faithful dog is an important character in the film adaptation of Lloyd C. Douglas' famous book

get some of that restlessness out of his system.

Something to Think About

Warner Brothers might well worry about this trip. Why? Because, Errol Flynn being what he is, might decide never to return to Hollywood and motion picture fame. Just like that—with a cool snap of his fingers. But he will come back. Warners are sure of that. They gave him a good reason for returning from the land of beyond.

Several months ago Errol joined Fawcett Writer William Ulman, Jr., in writing a story on some of the actor's personal adventures before he became a star. The title of that picture is *The White Rajah*. The idea came about during a lazy weekend in Palm Springs when Ulman was visiting Flynn, gathering material for a series of stories for MOVIE CLASSIC.

Out there in the desert the two reminisced together. Errol talked about a picture he would like to do, a picture full of the nostalgia of the South Seas, of thrilling incidents from his own life.

"Why don't we get together and turn that story into a scenario?" Ulman asked Errol after several hours discussion.

It was a deal. They worked it out, and sold the opus to Warners for a princely sum. And that's why the studio is sure that Flynn will come back!

Flynn's itinerary is the kind you love to speculate about. He will take the last scheduled steamer run to Tahiti and embark from there. (After this trip all regular ships will dispense with making Tahiti a port of call, there not being enough business to make it worth while.)

What he will do in Tahiti is still as much a mystery to Errol as to anyone else. How he will leave Tahiti for other islands is a matter for fate and time to decide.

But by and by a tramp steamer, a fishing schooner, or some wandering ship will drop anchor off the dreamy shores of Tahiti, and Flynn will find his time to move has come.

While restlessness is perhaps a prime factor in luring Errol away, he has a couple of real objectives in his Odyssey. Among the countless islands of the South Seas mandated to Japan is one particular lump of land that catches his fancy. He calls it The Lost Island, although of course it technically is nothing of the sort.

On this strange Lost Island, Japan is said to have secret fortifications. And Nippon is usually extremely reluctant to allow visitors within the sacred precincts. Nevertheless the intrepid Flynn will visit that island shortly, with the official permission of high Japanese dignitaries. And all because Errol, in one of his previous adventures, developed a close friendship with a son of one of these influential officials.

A Lost World

What Errol wants to see is not any secret military outpost, but to delve into the mysteries of a lost civilization which once flourished on the isle. Here, under the perpetual shade of dense palm groves, are the ruins of another era, said to rival even the mystical Mayan ruins of Central America.

That spells adventure to Errol. He is taking with him a 16 mm. camera with a supply of natural color film. When he returns he hopes to have adequate proof of another Yesterday in human existence.

From the Lost Island the actor will swing down to the East Indies, a familiar sight to him, for it was here that he had some of his most exciting adventures before he climbed the heights of Hollywood.

This country is the background of his *White Rajah* story. So somewhere along the line he will pick up a professional cameraman likewise afflicted with wanderlust, and film familiar scenes as a basis for the actual production. Didn't we tell you there was a good reason for Errol to come back to Hollywood?

Yes, Errol will come back, even if it wouldn't surprise anyone that he didn't.

He will make *White Rajah* and perhaps by then he will be willing to settle down for awhile. One cannot make any accurate predictions regarding his future. Errol is forever independent. And he loves the region "down under," where he had his first mad adventures with life.

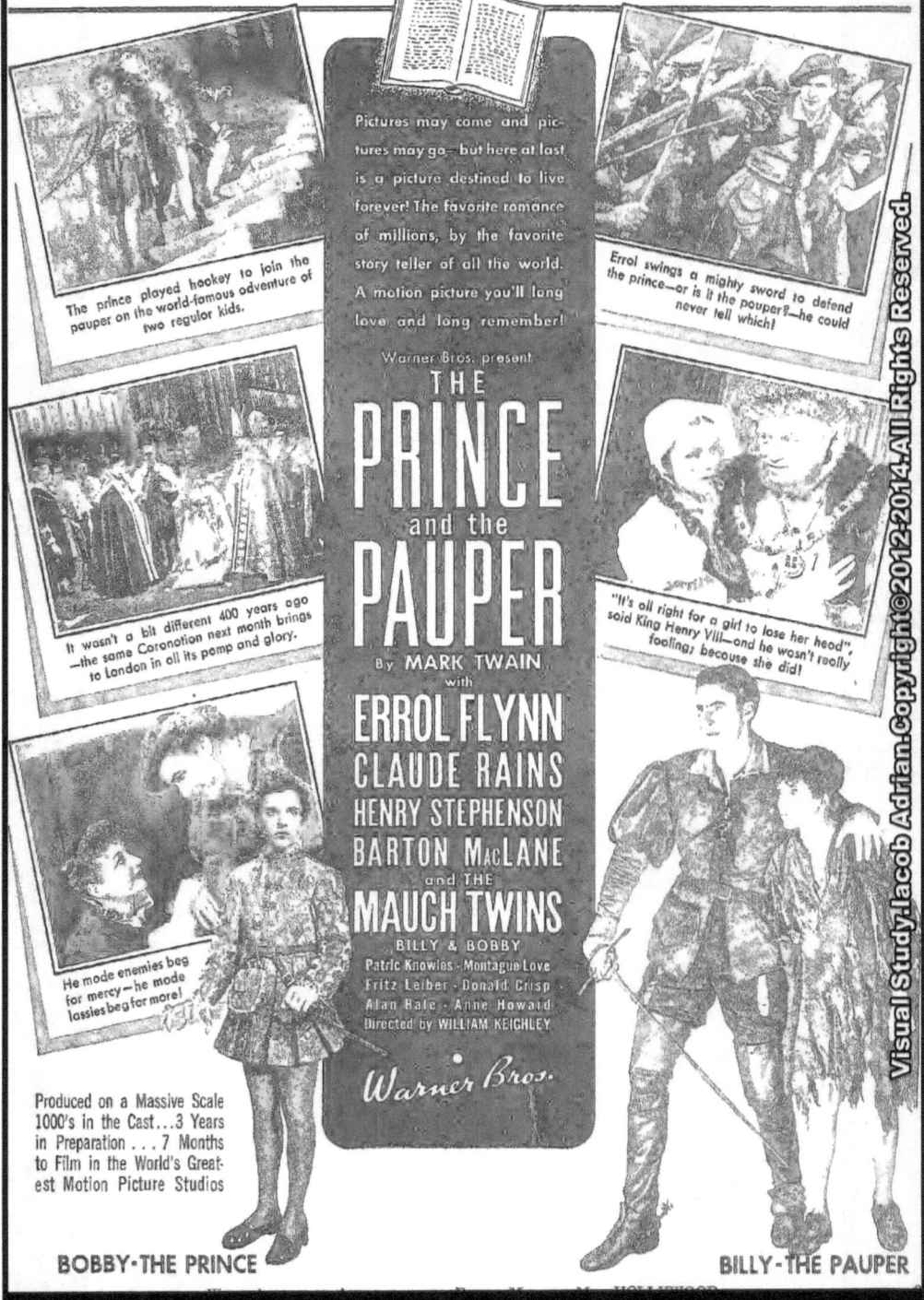

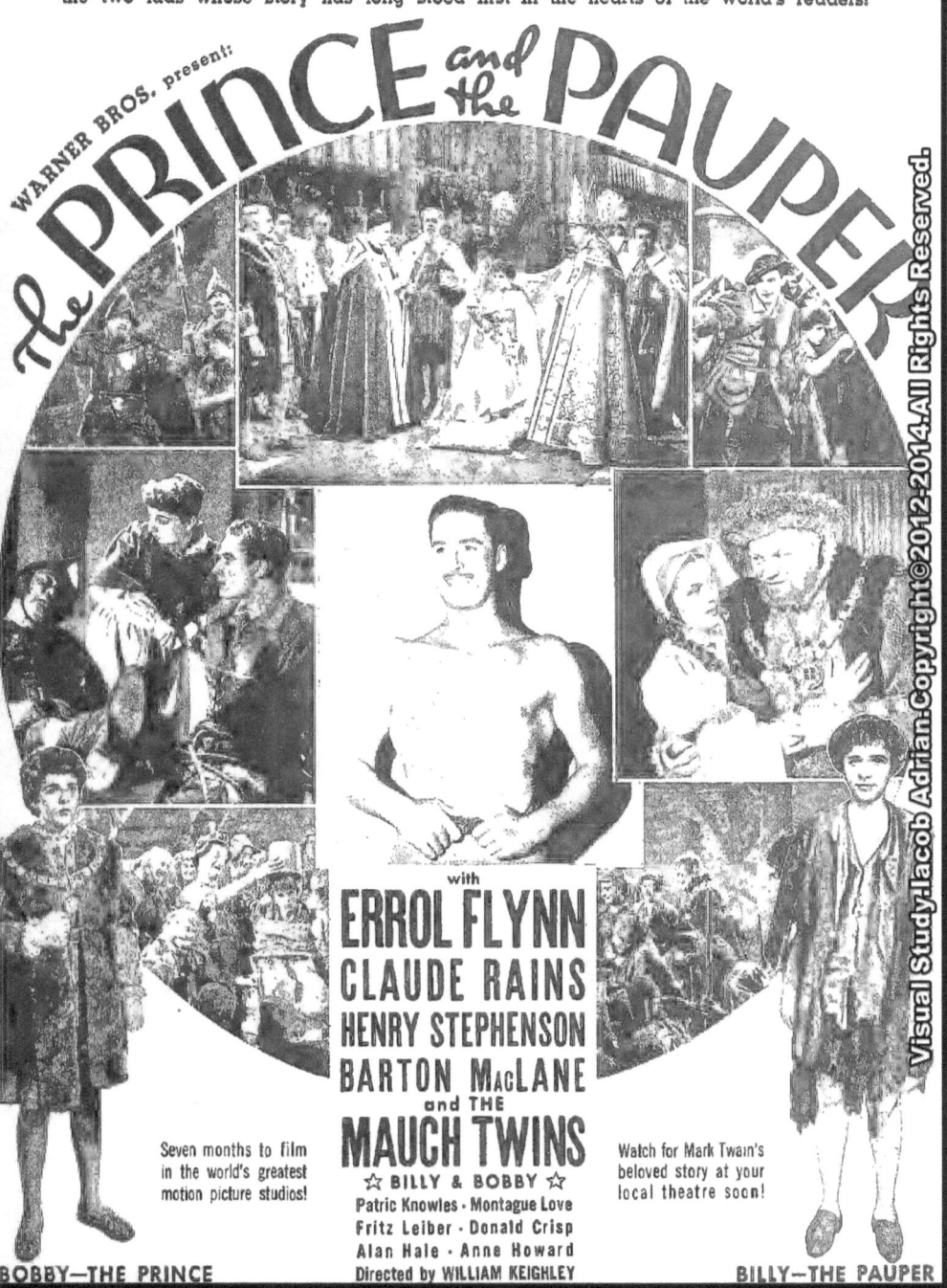

ROBIN HOOD IN HOLLYWOOD

If the bold outlaw of Sherwood Forest came to Hollywood, he might have some difficulty in pursuing his famous policy

By JESSIE HENDERSON

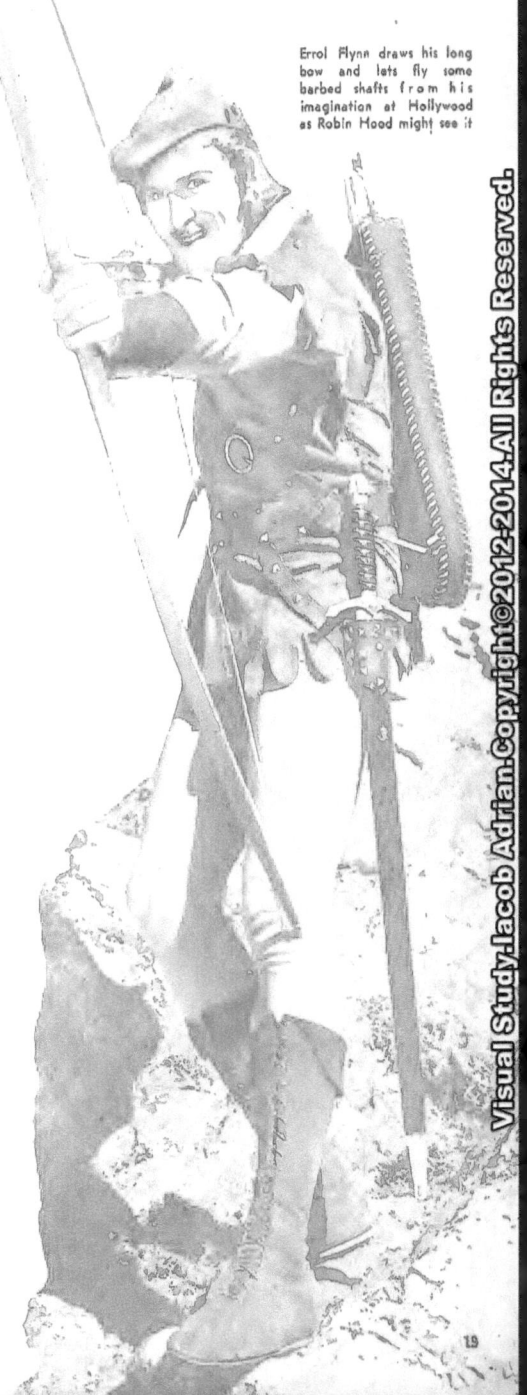

Errol Flynn draws his long bow and lets fly some barbed shafts from his imagination at Hollywood as Robin Hood might see it

■ "It's a bright, sunny afternoon such as we always have in Southern California," said Errol Flynn, ignoring a handful of clouds which as forerunners of the rainy season floated near the hills, "and down the Boulevard comes Robin Hood. He's blinking his eyes, because it's forever drizzling in Sherwood Forest, England, where he comes from, and he can't get used to daylight. But that isn't all he can't get used to, in Hollywood."

Robin Hood in Hollywood! There's where the talk had turned to what the doughty English champion of the unfortunate would do if he actually were in the cinema capital instead of just in the film that Warner Brothers has lately made of him. Errol Flynn considered the notion, eyes smiling, as he dropped into the studio commissary for a cup of coffee between the final indoor "takes" of the picture.

It should have been a cup of sack or a flagon of nut brown ale, if you wanted to stay historic, but you know what studio workaday rules are. Robin Hood never drank coffee. Eight hundred years ago, neither coffee nor tea was known outside the Far East and people in England, poor souls, had nothing to drink but liquor.

■ Fresh from eight weeks on *The Adventures of Robin Hood* location at Chico in Northern California, Errol was back with a tan as deep as the Sherwood outlaw ever had, an equal ability to shinny up oak trees, and a four-foot wildcat killed with his bow and arrow. After several months of practice, Flynn's as good with a bow and arrow as Cupid; better, because he doesn't miss so often. He slew that wildcat, right out in the woods, with the first arrow he'd ever aimed at anything but a stationary target.

"Immediately, the thing that gets him," Flynn mused, thinking of Robin Hood in Hollywood, "is how to redistribute the wealth. You know, Robin and his merrie men took it away from the rich and gave it to the poor.

"Well, he goes up to a modest looking flivver with a girl at the wheel in simple, unpretentious clothes—no brocade or ermine—and he tries to shower her with gold and jewels. Say, he tries to give her a scarfpin he's requisitioned from some wealthy dialogue writer and a dollar bill he took away from a realtor.

"So? So he finds it's Kay Francis, who has money enough in the bank, outside which she's parked, to buy Robin Hood and his entire collection of merrie men with perhaps the Lord High Sheriff of Nottingham thrown in. She doesn't want his gold and jewels. She says: 'Scat, before I call a policeman.'

■ "Policemen are no novelty to that chap, but he departs in great embarrassment and glimpses in the distance a snowy-haired mendicant in ragged clothes who looks as if he hadn't eaten in a fortnight. When Robin tries to thrust his benevolence upon him, the mendicant turns out to be Lionel Barrymore or Paul Muni or some other aristocrat of the screen made up for a picture role at heaven knows how much per week, and the lines of starvation have just been put on him by a make-up expert.

Robin Hood in Hollywood

"Naturally, Robin flees. He passes by without a second glance at a damsel sparkling with jewelry and gleaming with soft fabrics and furs, whose handsome big car is drawn up at the curb. He doesn't know it, but she's the kind of person he's been seeking. For she's a down-and-out extra who, because she has no work, is decked forth in borrowed finery and a borrowed hack so people will think she's prosperous and give her a job.

■ "This logic," Flynn added, "will all be beyond Robin. He lived in the uncomplicated days when you either had a castle or took in washing to pay taxes to support someone who had. Or skedaddled off to the woods and joined the Hood outfit."

For Robin Hood, as who doesn't remember, started life in possession of vasty estates but, bilked out of them by Sir Guy of Gisbourne (Basil Rathbone to you), he went away, mad, into the depths of Sherwood Forest and became an outlaw with a price on his head. His friend King Richard (Ian Hunter) was away on a crusade or something, so wicked Prince John (Claude Rains) planned to usurp the throne, and things were in a pretty howdy-do with people's estates getting confiscated right and left.

But eftsoon Robin was joined by brother-outlaws Little John (Alan Hale), Will Scarlet (Patric Knowles), Friar Tuck (Eugene Pallette) and Much, the miller's son (Herbert Mundin), together with everybody else who felt annoyed at being done out of their houses and lands. And at once they formed a band which, despite the efforts of the High Sheriff of Nottingham (Melville Cooper) and of the Bishop (Montagu Love), succeeded in making wealthy travelers "stand and deliver" the coins and trinkets which the outlaws proceeded to distribute among the needy.

Meanwhile, Robin rescued Maid Marian (Olivia De Havilland) from bad Sir Guy—she became Mrs. Hood—and fixed up a match between her attendant, Bess (Una O'Connor) and the miller's son, beside tipping off King Richard, who hurried right home, confronted Prince John, and grabbed back his crown in the nick of time. Lawks, lawks, more fun!

■ "Disgruntled by his experiences on the Boulevard," Flynn continued, his author's imagination going strong (he has written three books, including the current "Beam Ends"), "Robin drops in at a tavern for a beaker of mead, but all they sell is ice cream soda. While he's quaffing a jumbo chocolate special he learns that the lad upon the chair next to him is a cowboy who rides in something called movies but doesn't bring his horse into the drugstore because he doesn't own a horse; he only rides one. They're all talking with reverence about a knight yclept Buck the Jones.

"Mulling this over"—Flynn took another draught of coffee—"Robin sallies forth to watch an archery tournament about which he's heard. He finds the archers dressed in shorts, both men and women. But if he's fascinated by them, the lady archers are fascinated by him; because antelope's a pretty expensive and ritzy hat ornament this season, I'm told—" (wife Lili Damita must have a new bonnet)—"and Robin wears a Lincoln green hat made entirely of antelope.

"You can see how confused he'd be by a civilization where the women wear antelope and the men wear scanties. Pondering, Robin addresses a youth in doublet and hose—or slacks and sweater—as, 'Sirrah.' And finds it's a girl.

"I fancy this would be too much. He'd go away from there."

■ Between mouthfuls of coffee Flynn added that no doubt the outlaw'd be aghast at the thought of girls going on a diet to keep thin; girls were a buxom armful in his day. He'd be all of a jitter, too, over which fork and spoon, his chief culinary utensils having been fingers.

"Very likely," Errol went on, thoroughly

Errol Flynn turns on that Irish fascination triple strength for the benefit of the camera and the amusement of Gloria Blondell, sister of Joan and also under contract to Warners. Flynn is dressed in one of his *Robin Hood* costumes

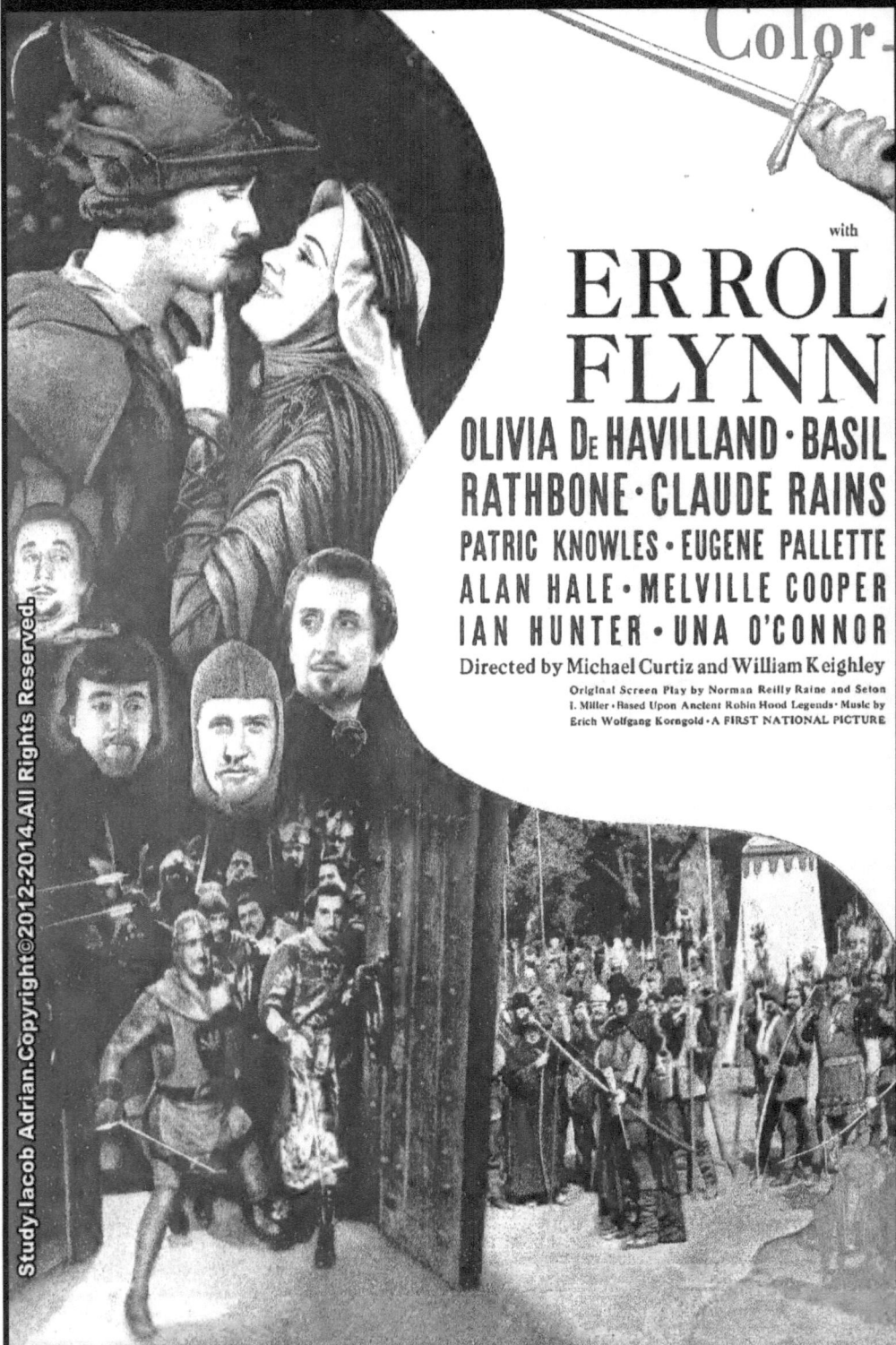

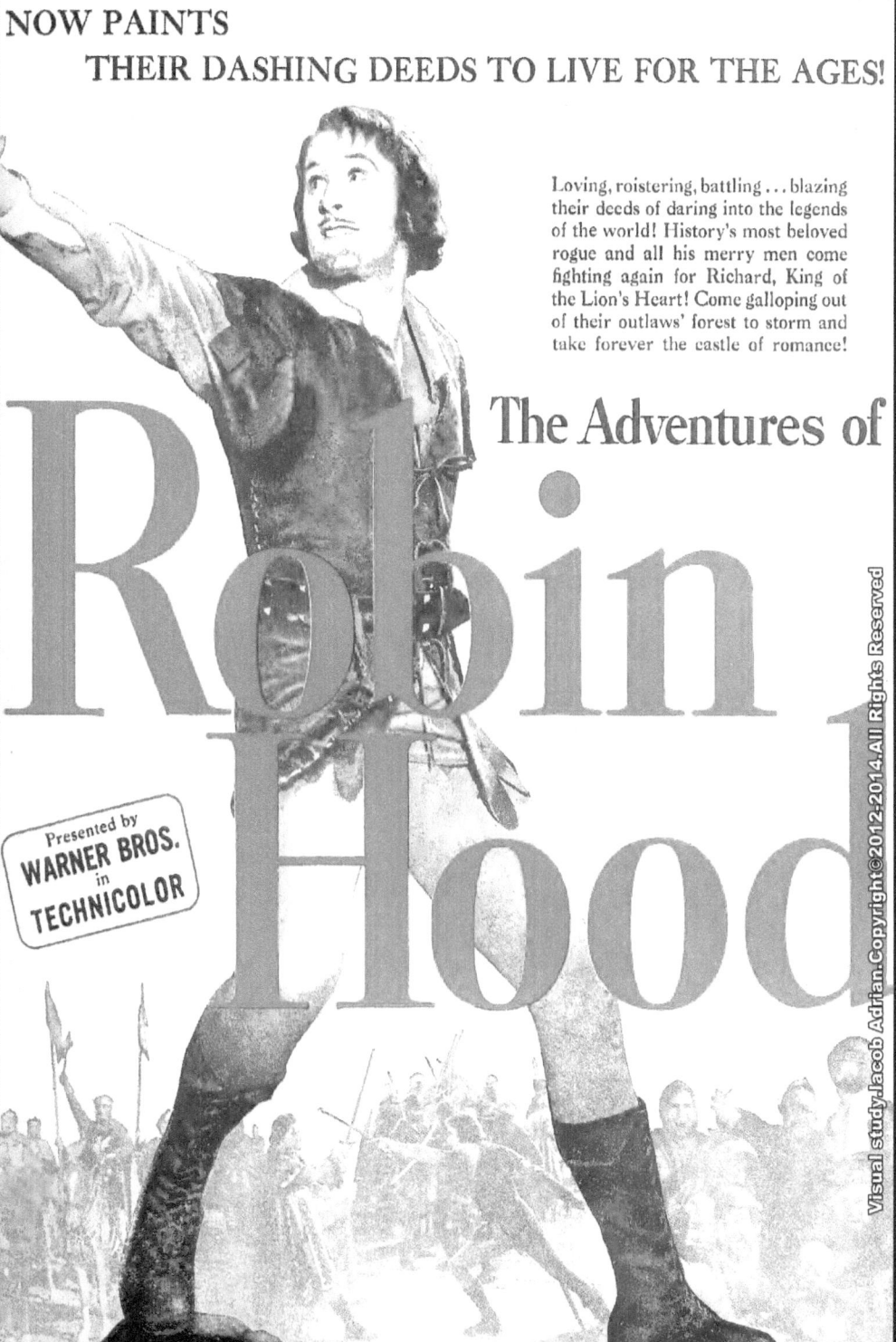

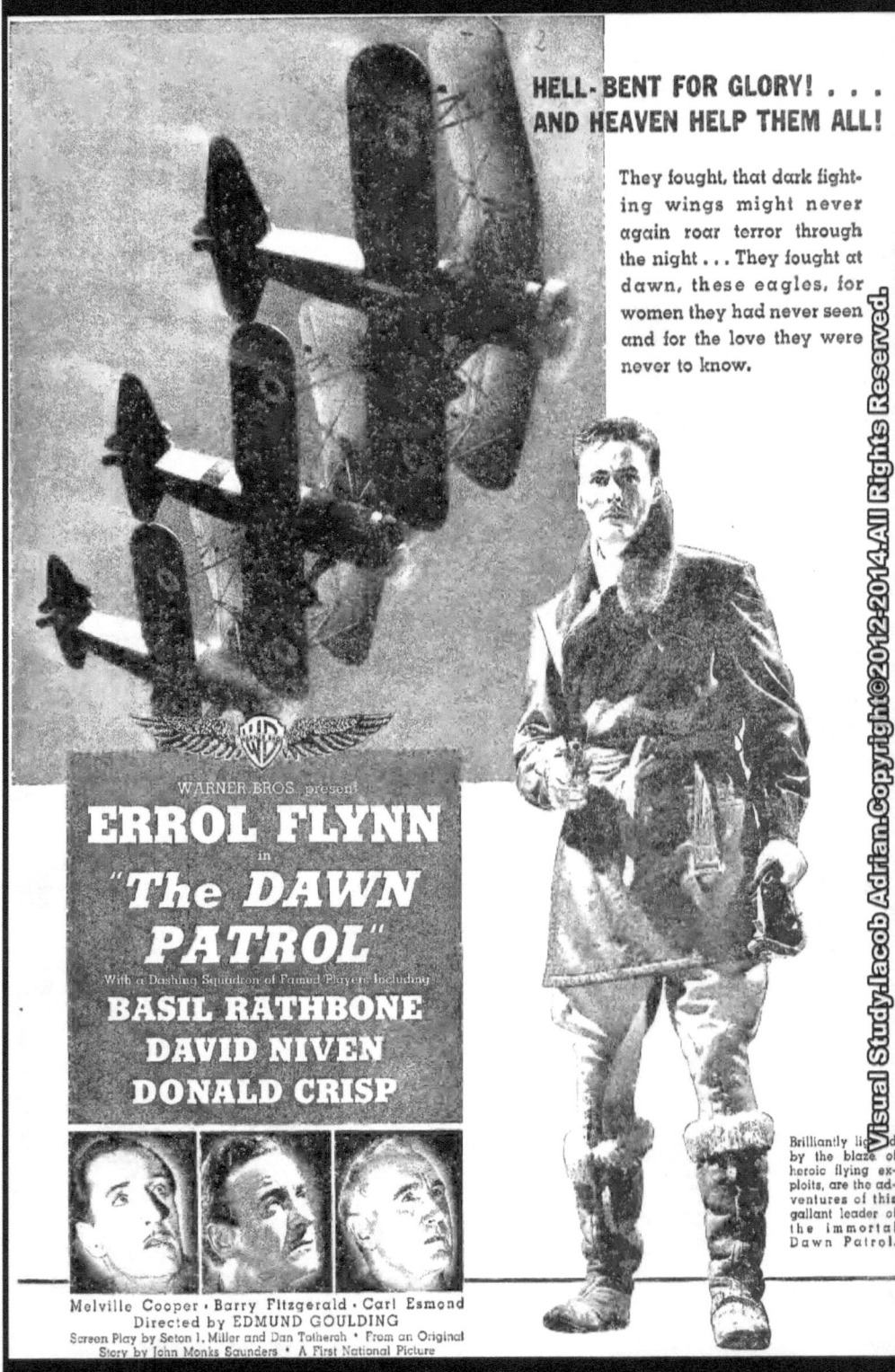

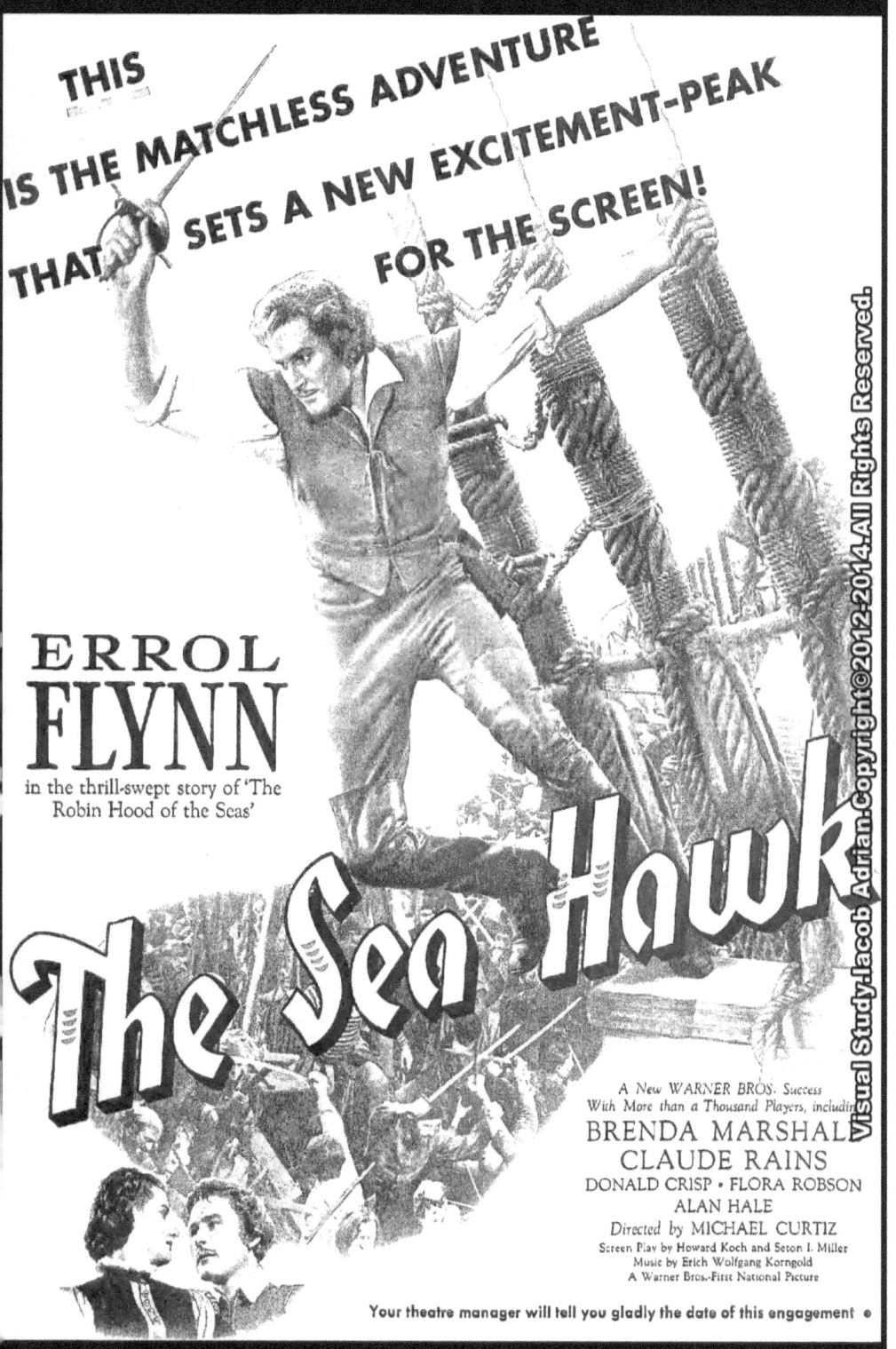

Errol Flynn's Biggest

Not fame, not fans, not his newest part are nearly so much of a problem as one determined Schnauzer who nearly landed his master in jail

When Mr. Errol Flynn adopted Arno into his heart and home, he little knew how much trouble he was borrowing!

One day his life was serene. He was master of his own soul, captain of his own ship, boss of his own household. There were no strings on Mr. Flynn's friendships, his goings-and-comings, his general behavior. Life, for him, was singularly free of complications. He was the living, breathing example of what people meant when they spoke of a "free soul".

Then Arno turned up and since then life hasn't been the same for Errol.

Errol may be the great Hollywood star, the man who pays the income tax, the guy whom the girls mob. But it's Arno who is the real boss of the Flynn menages. He expects, and receives, a certain deference from the servants, the milkman, the bread man, the Fuller Brush man. If anyone rings the doorbell, Arno is right there to pass inspection on the visitor. He may, and then again he may not, permit entrance.

A time or two Errol has been forced to sneak important visitors through the side door. Subterfuge galls Mr. Flynn, but he is forced to admire Arno's uncompromising stand where his personal opinions are concerned. After all, Errol himself does his own thinking—and why deny Arno the same right?

When Mr. Flynn first came to Hollywood his adventures in the far-flung corners of the earth were given considerable publicity. That venturesome quality is like the measles—awfully easy to catch. With it goes a keen sense of justice—of right and wrong. Of what's fair play and what isn't! Arno is not the only one in the house who has determined ideas about nearly everything!

Once, when Errol went on location, Arno was sent on a visit to the home of Flynn's closest friend. A cocker-spaniel happened to be the lord of this green pasture. Arno resented the indignity of sharing attention with a long-haired, floppy-eared comrade, by going on a hunger strike.

He bayed at the moon and made faces at the sun, and absolutely refused to have any truck with the ambulating, friendly cocker. All day long Arno sat in injured solitude, not even nosing the ground sirloin which was especially prepared for him. (Errol is kinda choosy about his food, too).

Again and again Arno asked himself—"What have I done to deserve this? I have been loyal. I haven't had more than one fight a day for a week. I haven't chased the neighborhood cats. I have been most careful to use the proper comfort station, but here I am—banished from the sight of the only person I care two hoots about! Is that fair?"

The hosts began to get a bit worried when Arno's hunger strike extended to two days. They opened the door to the wire enclosure, and made clucking noises to coax him out. Silly creatures, Arno thought to himself, as if he couldn't break prison with his own brawn and brain if there had been a chance of finding Errol. He wasn't dependent on a door for an exit.

Arno in the dog house But not for long! The free soul

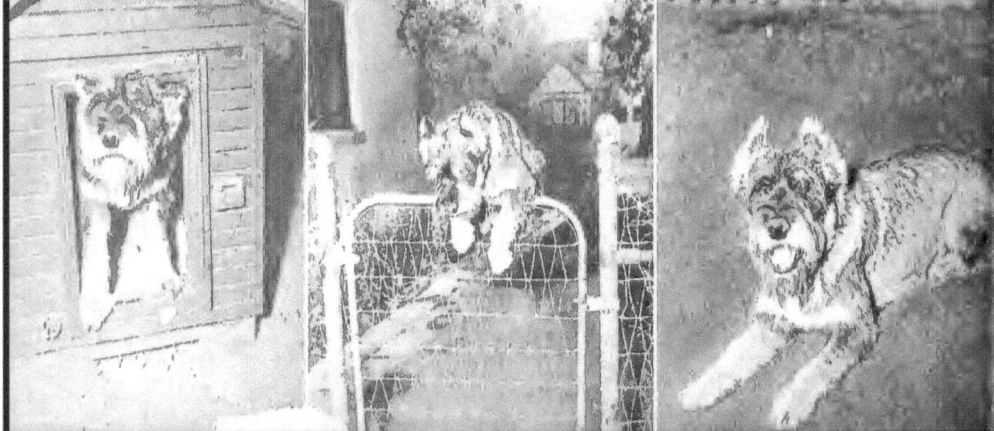

Problem

By SONIA LEE

(Errol, too, by the way, disdains difficulties. There's always a way to overcome them.)

Anger rose in Arno's breast. He would show these people how a gentleman and a scholar can solve a problem.

That night he set to work with fury in his heart. The locked door was a challenge. For hours on end, he dug deep beneath the wall. And long before the birds began their daily vocal lesson, Arno had a beautiful escape tunnel completed. There it was for all to see. And when his hostess came to look at him and to greet him cheerily, he was sitting belligerently in the exact center of the pen, with his eyes on the tunnel, as if to say—"I'm staying here of my own free will. If I had wanted to leave, if there was any purpose in leaving, I could have done a little digging long before this."

Neither Errol nor Arno hold with conventional restrictions or rules. One of these days Errol will dump his Fame in the waste-basket, pick himself up and go off to places unknown, to follow his fancy and his inclinations. To Errol, even a

On the *Dodge City* set rehearsing with Flynn

Arno, the gourmet, toys with his evening steak

Arno, the sportsman, in hot pursuit of goldfish

Arno, the prodigal, begs forgiveness at dinnertime

great career isn't worth the spiritual imprisonment it imposes. That will suit Arno right down to the ground. He doesn't much favor routine.

Arno might be a Houdini, for all the problem that chains and ropes present to him. Not long ago, when he was on vacation with Errol in Florida, they stopped at a very snooty inn. The haughty clerk gave Arno the fish-eye and announced that no dogs were allowed in the rooms. It was finally agreed that Arno would be tied up in the basement.

Arno, however, had other ideas. By what legerdemain he slipped the chain from his collar, and found his way, as true as a string, to his master's room is still a mystery for Sherlock Holmes. Exactly five times he was returned to his own quarters, and securely fastened. He was acquiescent and placid while the humans scolded. But the moment he was left alone, off would come the rope, and Arno would trot up the six flights and scratch at Errol's door for admission.

The management finally admitted defeat. The Governor of Illinois didn't have his dog in his suite; a duke from England, a minor King from Europe, and an important ambassador did not have their dogs in their suites. But Arno, the problem child, took matters into his own paws, cut red tape with his teeth and spent what was left of the night in his accustomed sleeping place—at the foot of Errol's bed.

With Arno for an example, it's no wonder that Mr. Flynn's quality of perserverance is becoming a matter of comment. (Note how long and devotedly he worked at archery to become expert for his part in *Robin Hood*.)

As a general rule, Arno is snobbish and haughty with other canines. They are so much dust beneath his feet, and recently that attitude and

Errol Flynn's Biggest Problem

his truculent behavior toward all dogs almost landed Errol in jail.

Errol and Arno were in Catalina over the week-end. Arno saw a dog he didn't like. Battle ensued, and when Mr. Flynn stepped in to separate the opponents, he found an angry gentleman shouting at him, and two husky policemen at his shoulders. Mr. Flynn was escorted to jail.

His misdemeanor was not having Arno on leash. He had several unflattering things to say about the man who insisted on his arrest. The officers were strangely non-commital, but Errol was nonchalant. The whole thing was silly, he declared in no uncertain terms. He added that he was sure the judge would understand and throw the case out of court with a few well-directed barbs at the complainant. Mr. Flynn smoked a cigarette, he threw it contemptuously on the floor as a sign of his annoyance. Order was called in the court-room.

Errol looked up. No, it *couldn't* be. But it was. The presiding judge before whom he and Arno were appearing was none other than the owner of the dog whom Arno had attacked so inadvisedly.

Mr. Flynn paid a whooping fine without any more argument.

■ The matter of the pelican is also worthy of record. Arno had never seen a pelican. He wanted to get acquainted when he first spied one. Not that he was getting social, but that giddy Peter Pan spirit in him, that childish curiosity, egged him on.

He took a jump in the drink. The pelican flew away, and that angered Arno no end. He was getting ready to swim to Asia to catch up with the pelican when

Wayne Morris with his fiancee, "Bubbles" Schinasi, have a word with Maestro Rudy Vallee at the Cocoanut Grove. This picture was taken shortly before marriage of the star and the tobacco heiress

Flynn stopped his plans. He got a pole, hooked it into Arno's collar, fished him out.

Three hundred people had assembled to watch the rescue. Arno, being anti-social, proceeded to shake himself dry in the thickest part of the crowd. The onlookers scattered like leaves in the wind. Mr. Flynn's face was very red. The studio is still settling claims for cleaning charges directly attributable to Arno's behavior.

■ Since signing up with Flynn, Arno gives promise of becoming somewhat of a critic on motion pictures. He has, willy-nilly, attached himself to the producer's staff at the studio. Each morning while Errol is busy elsewhere, Arno makes his rounds. He visits every stage, he watches a scene or two, he may even nip a director he doesn't like, and when his morning rounds are made, straight as a flight of a bird, he rushes to the stage where Errol is working.

Nowadays a player at Warner's isn't considered on the *arrived* list until Arno has stayed through an entire scene.

Once in a while Arno becomes a most important contributor to Errol's peace of mind and to his leisure. On *The Dawn Patrol* set Errol wanted every bit of rest he could get between scenes. And so he trained the pup to recognize assistant directors at a hundred feet and to stop them at twenty feet from the dressing-room door. Arno was friendly, but firm. So efficiently, firm that callers advanced only at risk to the seats of their pants. And so they had to stand off and shout: "Mr. Flynn—you're wanted on the set."

■ Arno takes life seriously. Loyalty to him is the greatest virtue. And so when Errol goes away and leaves him, he finds on his return a very silent and hurt dog.

After all, Arno's sensibilities are tender. He expects the respect, the fairness, the justice he gives others. Fail to give him his due, and the problem child goes off into corners and has nightmares which wakes up the neighborhood, or he develops a brooding spell which casts a pall of anxiety over the entire household.

Arno is definitely a product of an inner and secret life of his own. He has yearnings. He has maladjustments. He has dreams of grandeur.

He is, says Errol, an artist in living. If he has disappointments, he always finds a philosophy to make them easier to bear. He feels a strong kinship to his boss, because both of them have the itching foot, the desire for far wanderings. And both of them see things denied to other eyes. Perhaps that is why Arno is Flynn's greatest domestic problem as well as his dearest possession.

Take a long look at the quilted frock that Loretta Young wore dancing with David Niven. You'll see a lot of this graceful decoration

West of Dodge City There Was No Law
And There Virginia City Lay!

ERROL FLYNN

MIRIAM HOPKINS

Here—and brilliantly—is the breathless saga of the gallant 73 who charged through the boldest adventure of America's law-forsaken West..history's epic of the City of Gold that was built upon the lead of bullets. Its story is true—and its stars make it too thrilling to miss!

A New Dramatic Success by WARNER BROS. Producers of 'The Fighting 69th'

VIRGINIA CITY

Such a story and such irresistible entertainment has rarely been screened before

with RANDOLPH SCOTT
HUMPHREY BOGART
FRANK McHUGH • ALAN HALE
GUINN "Big Boy" WILLIAMS
Directed by MICHAEL CURTIZ

Visual.study.Jacob Adrian.Copyright©2012-2014.All Rights Reserved

Selling

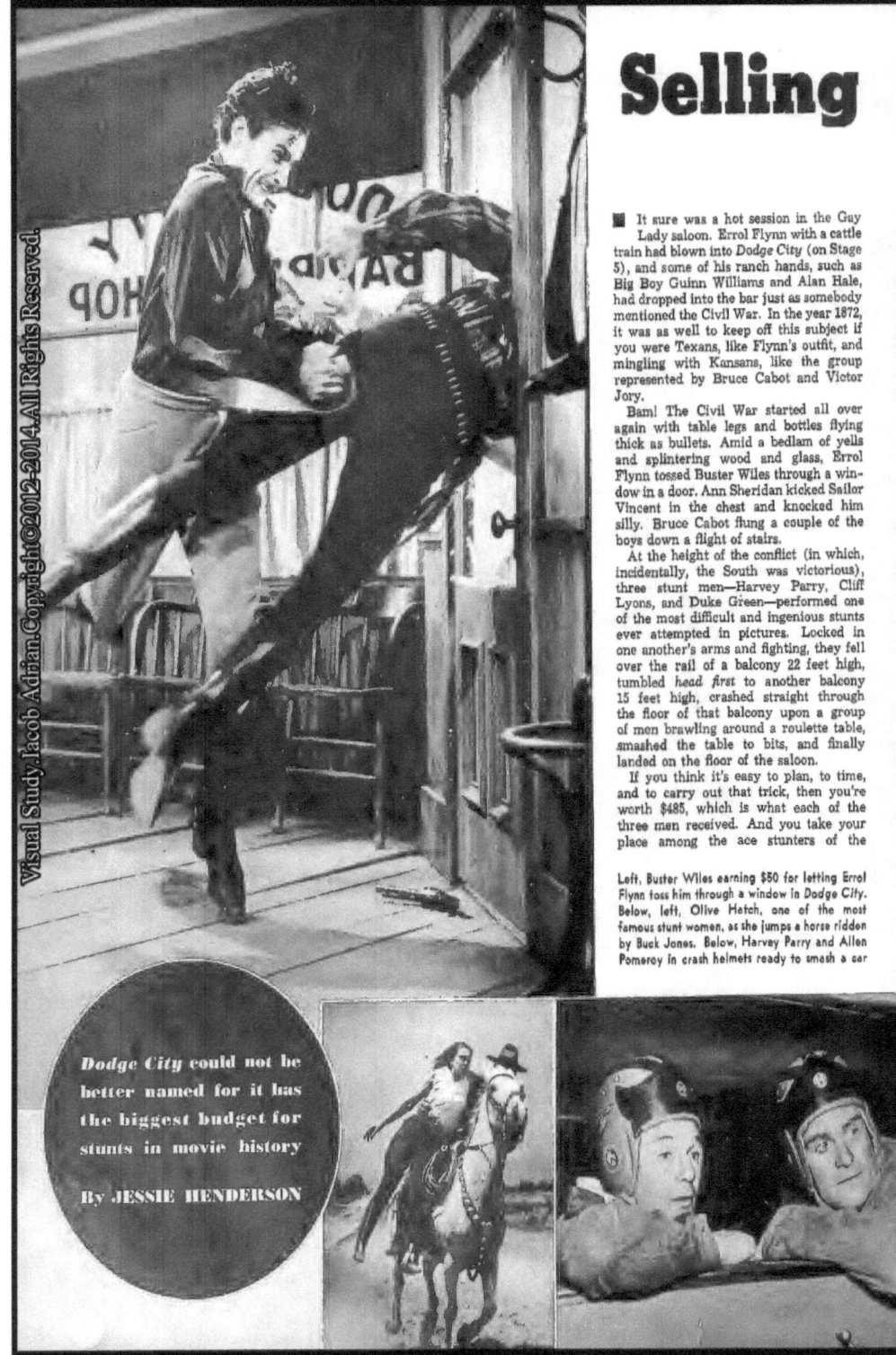

It sure was a hot session in the Gay Lady saloon. Errol Flynn with a cattle train had blown into *Dodge City* (on Stage 5), and some of his ranch hands, such as Big Boy Guinn Williams and Alan Hale, had dropped into the bar just as somebody mentioned the Civil War. In the year 1872, it was as well to keep off this subject if you were Texans, like Flynn's outfit, and mingling with Kansans, like the group represented by Bruce Cabot and Victor Jory.

Bam! The Civil War started all over again with table legs and bottles flying thick as bullets. Amid a bedlam of yells and splintering wood and glass, Errol Flynn tossed Buster Wiles through a window in a door. Ann Sheridan kicked Sailor Vincent in the chest and knocked him silly. Bruce Cabot flung a couple of the boys down a flight of stairs.

At the height of the conflict (in which, incidentally, the South was victorious), three stunt men—Harvey Parry, Cliff Lyons, and Duke Green—performed one of the most difficult and ingenious stunts ever attempted in pictures. Locked in one another's arms and fighting, they fell over the rail of a balcony 22 feet high, tumbled *head first* to another balcony 15 feet high, crashed straight through the floor of that balcony upon a group of men brawling around a roulette table, smashed the table to bits, and finally landed on the floor of the saloon.

If you think it's easy to plan, to time, and to carry out that trick, then you're worth $485, which is what each of the three men received. And you take your place among the ace stunters of the

Left, Buster Wiles earning $50 for letting Errol Flynn toss him through a window in *Dodge City*. Below, left, Olive Hatch, one of the most famous stunt women, as she jumps a horse ridden by Buck Jones. Below, Harvey Parry and Allen Pomeroy in crash helmets ready to smash a car

Dodge City could not be better named for it has the biggest budget for stunts in movie history

BY JESSIE HENDERSON

Danger by the Day

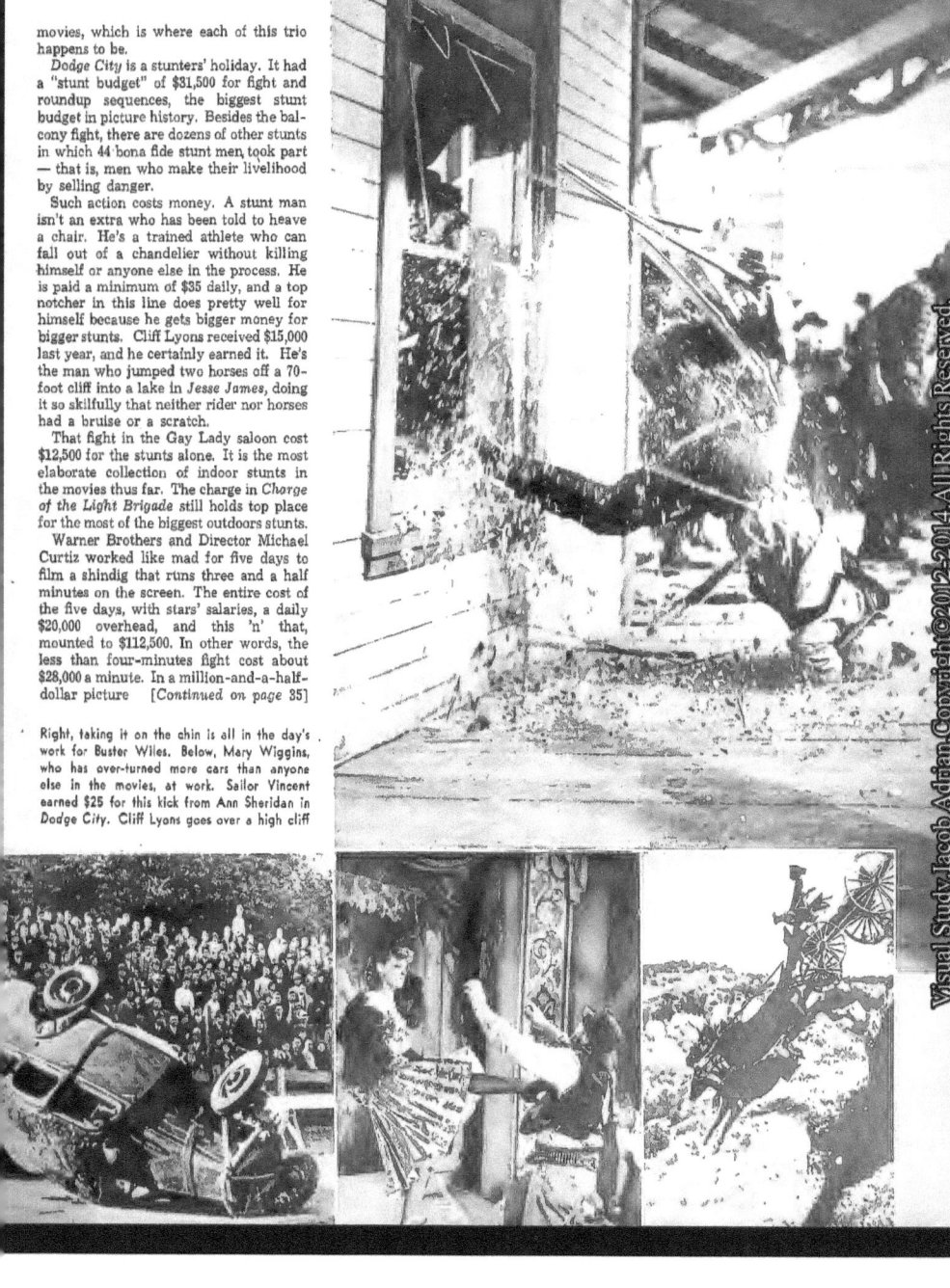

movies, which is where each of this trio happens to be.

Dodge City is a stunters' holiday. It had a "stunt budget" of $31,500 for fight and roundup sequences, the biggest stunt budget in picture history. Besides the balcony fight, there are dozens of other stunts in which 44 bona fide stunt men took part — that is, men who make their livelihood by selling danger.

Such action costs money. A stunt man isn't an extra who has been told to heave a chair. He's a trained athlete who can fall out of a chandelier without killing himself or anyone else in the process. He is paid a minimum of $35 daily, and a top notcher in this line does pretty well for himself because he gets bigger money for bigger stunts. Cliff Lyons received $15,000 last year, and he certainly earned it. He's the man who jumped two horses off a 70-foot cliff into a lake in *Jesse James*, doing it so skilfully that neither rider nor horses had a bruise or a scratch.

That fight in the Gay Lady saloon cost $12,500 for the stunts alone. It is the most elaborate collection of indoor stunts in the movies thus far. The charge in *Charge of the Light Brigade* still holds top place for the most of the biggest outdoors stunts.

Warner Brothers and Director Michael Curtiz worked like mad for five days to film a shindig that runs three and a half minutes on the screen. The entire cost of the five days, with stars' salaries, a daily $20,000 overhead, and this 'n' that, mounted to $112,500. In other words, the less than four-minutes fight cost about $28,000 a minute. In a million-and-a-half-dollar picture [*Continued on page 35*]

Right, taking it on the chin is all in the day's work for Buster Wiles. Below, Mary Wiggins, who has over-turned more cars than anyone else in the movies, at work. Sailor Vincent earned $25 for this kick from Ann Sheridan in *Dodge City*. Cliff Lyons goes over a high cliff

Selling Danger by the Day

they felt it was well worth while.

Stunts and stunt men, you see, are vital to action films, and, as a rule, it's the action films that make the most money. Stunts are a special province. Even with all the courage and good intentions in the world, nobody can perform them successfully week after week except the people who have devoted years to learning how. Therefore, when the script calls for a leap from a mountain top, or for the overturning of a car at high speed, the casting office summons one of these men—or women—who commit "suicide" every day and get away with it.

Stunts are hazardous stuff, but they are worked out beforehand to eliminate as much of the hazard as possible. "It isn't just, 'So help me, here we go!'" Harvey Parry explains, "we figure every angle." A stunt man despises the hot-headed amateur who runs an unnecessary risk. Most of the A-1 stunters have refused, from time to time, to do jobs which involved almost certain injury. The experts won't "take a chance"—at least, not what they consider such—and 18 of the top-notchers, banded together loosely in a semi-social organization, recently were granted insurance by Lloyd's. They pay about the same rate as police or firemen. "Stunt men," says Harvey Parry, capping it, "are the slowest-driving motorists on the road. They know what cars can do!"

The "Gay Lady" brawl wasn't the only scene in *Dodge City* (well named!) which required the skill of stunt experts. Half a dozen of them went on location at Modesto and, among other activities, let themselves be shot off horses.

Sam Garrett was of this number. He is the world's champion roper, and can rope cattle while standing on his head. So was George Williams, whose horse, Goldie, at a certain signal will fall down at full speed and roll over on its rider. Cute pet, eh? For an end-over-end—that is, he goes over the horse's head and the horse somersaults over him—he draws $250. For letting the horse roll over on him he draws about $300, depending on whether the ground is sand or rock. Williams did 90 per cent of the falls in *The Charge of the Light Brigade*.

One of the most exciting *Dodge City* stunts out on location was the burning of a baggage car with several cowhands inside. Dangerous, but the stunt men moved fast, right through the flames, and made it without casualties. Another good moment was when Cliff Lyons, for $250, fell off a hearse that was careening over the prairie with a kidnaped marshal in it. Several of the men also jumped from moving trains to the backs of horses, for from $75 to $100. Naturally, the sums vary according to the importance of the feat. Sailor Vincent was paid $25 for letting Ann Sheridan kick him in the chest, Buster Wiles $50 for letting Errol Flynn throw him through that door.

It's merely a matter of learning how, what and when, the experts explain. Of

course there are few actors (stunt men don't consider themselves actors though often they play "bit" parts) who have the training to do stunts although good gymnasts and athletes like Victor Jory, Guinn Williams and Alan Hale are adept at these things, and Jimmy Cagney in a recent picture made a flying leap to a horse's back "just for fun." Many of the regulation stunters are former rodeo stars, others were circus men.

For example, Yakima Canutt, one of the best, was a champion cowboy and rodeo king; Allen Pomeroy, a college athlete; Duke Green, a professional diver and acrobat. Otto, Victor, and Tom Metzetti, who did a majority of the falls down stairs and off roofs in *Gunga Din*, were circus stars. Paul Mantz, Tex Rankin, Fred Clark, and Dick Grace have gained first rank reputations for "airplane stuff." They do wing-walking, crashing planes, swinging by ropes, whatever you care to suggest. Paul Mantz did that terrific power dive in *Wings of the Navy*. Clark in *Devil Dogs of the Air* brought a plane down and bounced it gaily over two ambulances at the airport.

■ Hollywood admires the stunters tremendously, knowing they have saved many a picture from the curse of the commonplace, yet on the stages they are regarded with well-justified suspicion. Accustomed to danger, they are inclined to play sort of rough when several of them get together.

Some of these practical jokes have become famous. On location for the *Valley of the Giants*, his fellow stunt men tied Sailor Vincent—an unusually sound sleeper—to his bed, put smoke bombs around and waited. When Sailor woke to find the room full of smoke, he jumped right out the second story window with the bed strapped to his back. Even half awake, he remembered to relax as he fell and escaped unhurt, but he threw an awful scare into his playmates.

■ When the *Kid from Kokomo* was shooting, stunt men Harvey Parry was supposed to be knocked unconscious during a fight. By prearrangement, Parry pretended to be really unconscious. He remained all doubled up while they carried him to a spot on the sound stage near Joan Blondell.

"Is his back broken?" somebody inquired. "I'll fix it!" said stunt man Allen Pomeroy. He seized Parry's limp form and vigorously bent it backward, as if to straighten it. A most horrible creaking and crunching of bones was heard. The joke succeeded too well. Joan, who hadn't noticed the apparatus from which the creaking came, passed out cold.

Ah, well. Just carefree pranksters. At that, each and every one of them admits you have to be "a little crazy" to make stunts your living.

Yet, if you met these people, you'd never think they were "a little crazy" or, for that matter, addicted to dangerous exploits. Harvey Parry, for instance, who plays the violin and has a young daughter in art school, lives sedately in San Fernando Valley. Outside working hours, he won't even trip over a garden hose. Cliff Lyons, a six-footer, speaks in a gentle voice, likes early American furniture, and owns one of the most charming little homes in Hollywood.

Olive Hatch of the long, dark hair—for all the stunters are not men—is a graduate of U. C. L. A., a former newspaper woman, national champion in the 100-meter free-style swim, member of the Los Angeles Athletic Club team that holds the world record for the relay (swimming) race. Her specialty is leaping to the backs of horses ridden by Buck Jones, or falling over backward in chairs as she does in *The Girl Downstairs*. And there's Mary Wiggins, poised and beautiful, who holds the women's professional high diving championship of the world, flies a plane, and thinks nothing of dousing gasoline over herself, setting herself afire, in an ordinary garageman's suit, and diving from an 86-foot platform into three feet of water, the surface of which is covered with flaming gasoline. She does this to amuse the customers at county fairs.

■ A mad crew, my masters! Yet ask them about their "most dangerous stunt" and they'll tell you seriously that there isn't such a thing. They've planned them all in advance with painstaking care

NOW PAINTS THEIR DASHING DEEDS TO LIVE FOR THE AGES!

Loving, roistering, battling...blazing their deeds of daring into the legends of the world! History's most beloved rogue and all his merry men come fighting again for Richard, King of the Lion's Heart! Come galloping out of their outlaws' forest to storm and take forever the castle of romance!

The Adventures of Robin Hood

Presented by WARNER BROS. in TECHNICOLOR

It's Here!
The thundering story that challenges all filmdom to match its excitement!
"Iron Rails to Kansas... Iron Nerves from there on!"

WARNER BROS. PRESENT
ERROL FLYNN
OLIVIA DeHAVILLAND
in
Santa Fe Trail
A thousand miles of danger with a thousand thrills a mile!

with RAYMOND MASSEY
RONALD REAGAN · ALAN HALE
Wm. Lundigan · Van Heflin · Gene Reynolds
Henry O'Neill · Guinn "Big Boy" Williams
DIRECTED BY MICHAEL CURTIZ

and tried to eliminate every peril. So ask about the "most difficult stunt." We—ell—

"Once," said Harvey Parry, "in *The Eleventh Hour*, I made a 110-foot dive into the sea. I had to clear 20 feet of protruding cliff and try to land when the wave was in. With the wave in, I had 12 feet of water. With the wave out, about 4. From that height, it takes you around three seconds to fall, and you're hitting the water at 80 miles an hour. It needed figuring, but I made it okay. Only, at that, there was a piece of wood swirling around in the wave. It hit me in the chest and knocked me out."

Most good divers, he explained, hate to jump from heights, instead of diving, "because they get the sensation of falling." He has been national diving champion and national amateur boxing champion. And he is, by the way, a fatalist.

No wonder. Because after jumping and diving from masts and cliffs, after skidding and overturning cars and running locomotives off tracks, and coming out practically unscathed, he slipped from a six-inch high sidewalk in *Call of the Wild*, and broke three vertebrae. The greatest contrasts he's known were his stunts in *Call of the Wild* and *They Made Me a Criminal*. For the first film, Parry and Duke Green had to break the ice to get into a river for a boat smash scene, with the temperature 22 degrees below. For the second film, Parry had to run the tops of box cars at Palm Springs in summer, with the thermometer at 135 in the shade. The rungs of the iron ladder on the cars were so hot they burned his hands, even through gloves.

Parry is a fine boxer, and is in great demand for fight scenes. He says that in pictures he has lost "three world championships! I knock 'em down often, but I never win. I've been in over 100 fights and never won yet. In *The Irish in Us*, Cagney and I fought for three days under the hot lights. Both of us were in good condition, but Cagney lost 9½ pounds and I lost 5."

Many times Parry, like other stunt men, has missed disaster by a hair. But he never has been nearer it than in *The Conquerors* when, with Ann Harding, he did a runaway-team scene. When the wagon broke up and overturned, Parry got hit on the head. Somewhat dazed, he knew that he must race back along the railroad track and pull a dummy from the ruins of the wagon before a locomotive, coming at 40 miles an hour, struck it.

"I was confused and couldn't judge the distance between the engine and myself," he said, "I rescued the dummy, but I could have touched that engine as I jumped away from in front of it."

■ And, still speaking of risks. . . . "The amateur is the risk," Parry added. "The youth who turns somersaults down on the beach and believes his friends when they say, 'You ought to be in pictures.' The biggest risk of all is the ambitious extra who tries to horn in on the scene and musses up a stunt you've spent weeks in making safe, like the extra who grabs a chair and throws it in a fight, not realizing that a stunt man will throw the right chair—a breakaway—or else not hit anyone. When a star makes a mistake, they do a retake. But if the stunt man makes a mistake, usually they have to get another boy."

Duke Green, who among other accomplishments can fall off a horse at the right time and place, frightened Parry and the rest of them half out of their wits not long ago. He fell off the horse, but unexpectedly the horse fell on Duke. When they picked the stunt man up, he was making dreadful sounds: "Awrgh! Awrgh!" After a minute, with people bending anxiously over him, he gave a mighty wriggle and exclaimed: "Doggone it! I swallowed my tobacco!"

Two of the hardest stunts figured out by Cliff Lyons were a jump into an automobile, and a jump from the top of a dam. The automobile jump, from a roof to the car, was a fussy thing because Lyons had to jump at one angle while the car at 45 miles an hour was going at another. "If we'd both been traveling in the same direction, it wouldn't have been anything," he explained modestly.

The leap from the dam was tough. Lyons often had made higher leaps, but the rocks at the dam's foot were a menace. By painstaking measurement he found a space—only one—between those rocks which would almost exactly fit his body. That's what he aimed for, and if you suppose it's a cinch. . . .

■ Stunters say it's the little, unconsidered things that make the hazards. The forgotten milk bottle on the ground when you put a car through a brick wall. A stray nail. An electric light globe that may drop on your head. Mary Wiggins says diving, afire, into a flaming pool isn't so risky as crashing motorcycles into houses or overturning cars. She has overturned more cars—at high speed, too—than any man in the movies and she's done it not only in the movies but at numberless county fairs. She has done 125 motorcycle wall crashes and 30 auto wall crashes. At one stretch in fairs, she turned over 77 cars in 11 weeks, one a day.

Yet, though they all say the hazards are eliminated as much as possible, they all echo Mary's, "Definitely NO!" when asked if they advise other boys and girls to take up stunting, "Too much strain, mental and physical, for compartively too little pay." Come right down to it, nothing really can pay you for the stuff you do as a stunter. Not, you understand, that any of the stunt men or women crave any other sort of work. . . . No, siree!

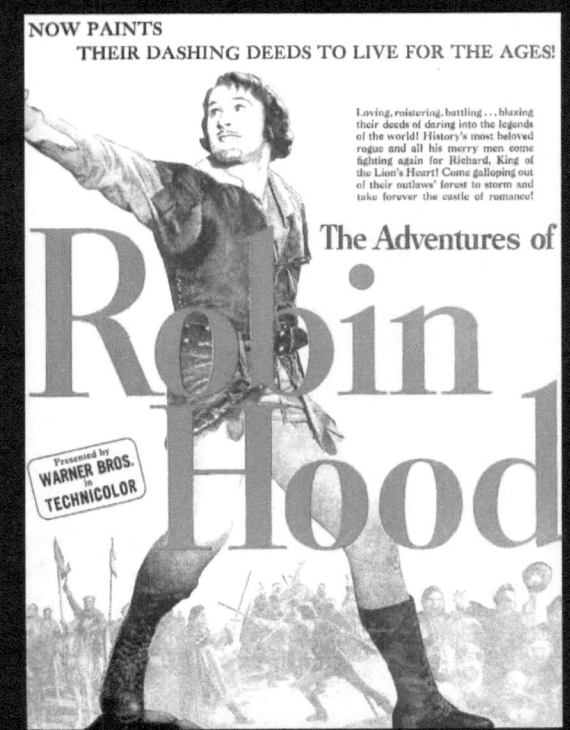

NOW PAINTS
THEIR DASHING DEEDS TO LIVE FOR THE AGES!

The Adventures of
Robin Hood

Loving, roistering, battling . . . blazing their deeds of daring into the legends of the world! History's most beloved rogue and all his merry men come fighting again for Richard, King of the Lion's Heart! Come galloping out of their outlaws' forest to storm and take forever the castle of romance!

Presented by
WARNER BROS.
in
TECHNICOLOR

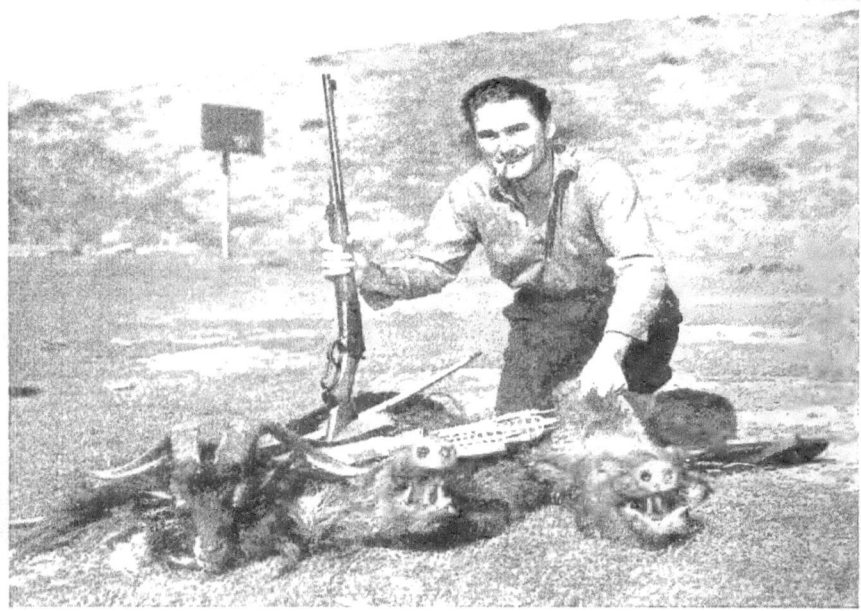

To celebrate the completion of *Dodge City*, Errol Flynn went hunting for wild boar with gun and arrow, and here he is with the kill, two full grown wild pigs and a mountain goat. Flynn starts work soon on three new films, *The Sea Hawk*, *The Knight and the Lady* and *The Adventures of Don Juan*

Young Niven played this trick three times with success. The fourth time, they caught him.

On another occasion, he decided to relieve the tedium of the study hour by having all the pupils go berserk simultaneously. At a given minute, each boy was to fling his books in the air, kick over his desk, and scream. Since the entire school would be involved in the prank, Niven figured that no one pupil would receive drastic punishment. The other boys agreed.

"The given minute arrived," Niven related the incident. "I stood up and flung my books in the air and waved my arms and yelled, 'Yay! Yo! Yaah!' Then I stopped short. I was the only one yelling. Nobody else had stood up. They all peered over their books at me with an air of innocent horror. I'd been framed!

"Naturally, the instructor thought I'd gone crazy. He hustled me downstairs to the school nurse, who decided it must be a nervous breakdown. They almost sent me to a sanitarium. I had a dreadful time talking myself out of it."

Some memory made him laugh abruptly. The Niven popularity, he declared, was a good bit exaggerated. No man could be half as popular as I'd tried to make him out, he said.

"Trouble with Hollywood, it has only a two-word vocabulary. I mean, for man-and-woman friendships. 'Thatway,' or 'pfft.' There's apparently no middle course in the public mind or the public prints.

"You take a girl out to dinner and a photographer crawls from under the tablecloth. Before the evening ends, the girl is so self-conscious at being heralded as 'thatway' about a casual friend that she never wants to see you again; and you never have a chance to find out whether you could become anything but a part of an embarrassing memory.

"A chap who prefers to remain a bachelor has a good excuse if he's in pictures," Niven pointed out. "The average man catches the 8:10 train in the morning, catches the 5:20 in the afternoon. His wife knows when he will reach home. His dinner is ready when he arrives.

"Not so the film actor. He may have to leave for the studio at five in the morning, if his make-up job is intricate. He may work all night and not be home before five the next morning. On the other hand, he may have weeks at a stretch when he doesn't work at all. Or he may be sent hundreds of miles away for a fortnight on location, or told to pack up at an hour's notice to go to Alaska or the South Seas.

"He has no regular work routine whatever. And that's hard on a wife. As I understand it, a wife likes a husband to be home when dinner's ready.

"I want to go to Sun Valley on my next holiday, but if a chap's married . . . You have a week between pictures and you hurry home and say, 'Dear, is it all right if I go to Sun Valley tomorrow?' And if your wife says 'No'—then there's nothing else for a chap to say, is there?"

And there you have it. What a chap likes most (at the present writing, anyway) is freedom.

The Lady and the Knight

By JESSIE HENDERSON

Bette Davis, in heavy make-up, as the 45-year-old Elizabeth, fights her love for ambitious young, dashing, obstinate Essex who is played by Errol Flynn

Take a trip backstage and watch the filming of the tragic story of the love of Elizabeth and head-strong Essex

■ It had been a pretty tough day for the Queen. The courtiers were a-muttering in Whitehall Palace corners against her sweetheart, handsome young Essex. The Irish rebels were on the rampage. Essex was looking sidewise at a dark-eyed lady-in-waiting. And the royal flame-colored velvet robes, studded in diamonds, gold and topaz, weighed 97 pounds as against Queen Elizabeth's own weight of 110 . . . with the temperature under the lights on Stage 9 at 120 degrees.

Yes, a tough day, and bound to grow tougher. For *now* they wanted her to break mirrors! "It isn't bad luck if you do it on purpose," they soothed.

"Whoof!" ejaculated good Queen Bette Davis, dropping into her great canvas chair before the empty fireplace in the "Queen's Closet." The

chair, placed there temporarily to catch the Queen before she sank under the weight of her velvet splendor, was especially constructed by Warner Brothers' prop department to accommodate the wideflung regal skirts.

Somebody opened the sound stage doors. Hot sunlight and a wisp of sultry breeze poured into the stone walled "Closet"—a parlor, really—with its high, narrow, stained glass windows decked out in armorial shields. "Whoof!" said the Queen again.

"Cigarette?" asked Sir Walter Raleigh —as well he might. It was Raleigh, you remember, who first brought tobacco to England from the colony of Virginia, which had been named for the Virgin Queen. Good Queen Bess tried a pipeful of it once, and pronounced the stuff not bad. Good Queen Bette got out a 12-inch paper holder and carefully put into it the cigarette which towering Sir Walter (Vincent Price, 6 ft. 4½ ins., from the New York stage) offered from his pack. She looked anxiously after her gigantic lace ruff while he gave her a light.

"Anybody wants to be queen," she remarked to Tibbie, the pet Scottie, "can have it." Bette ought to know her own mind on that subject; she's lately been the Empress Carlotta, too. Tibbie gave a feeble flick of the tail in reply. Since Bette had donned that red Elizabeth wig, Tibbie wouldn't come out from under the dressing table. Before they toned the wig down and tamed its curls to royal dignity for technicolor camera requirements, Bette, herself, said she looked like Harpo Marx.

She didn't look like Harpo on the day I saw her. She looked like a weary woman of 45 trying to appear girlish, without benefit of beauty salons, for a lover of 25 —and she'd had the dickens of an argument with the makeup department in order to achieve that appearance.

They wanted to glamourize her. "What!" cried Bette with vehemence — for she knows her history—"*glamour*! For Elizabeth! In those days, she was absolutely a hag, and I'm going to look like a hag or I won't play the role!" She added: "Why, the whole point of the plot is Elizabeth's fear that a youth couldn't love her, and the fact that the youth doesn't."

So Bette plucked her eyebrows (Elizabeth's were very thin), and shaved her forehead hairline (because Elizabeth's hair grew scant), and had them do things to her face in the matter of wrinkles and pouches which very few Hollywood stars would have permitted, much less insisted upon.

So, she looked like Elizabeth at 45 or better, fading, but still vain; jealous, anxious, suspicious, eager to be reassured; a great Queen and a proud woman, able to give her hot-headed young lover every splendid gift he craved, except the gift of youth to match his youth..... Why, Bette had wanted to play one scene without the wig, practically bald! She wanted to play *Elizabeth*—not a glamour tootsie.

"What's Essex up to *now*?" demanded Bette, glancing toward a corner of the stage whence arose hoots of merriment. Essex (Errol Flynn) in crimson velvet doublet and hose, slashed with gold, his

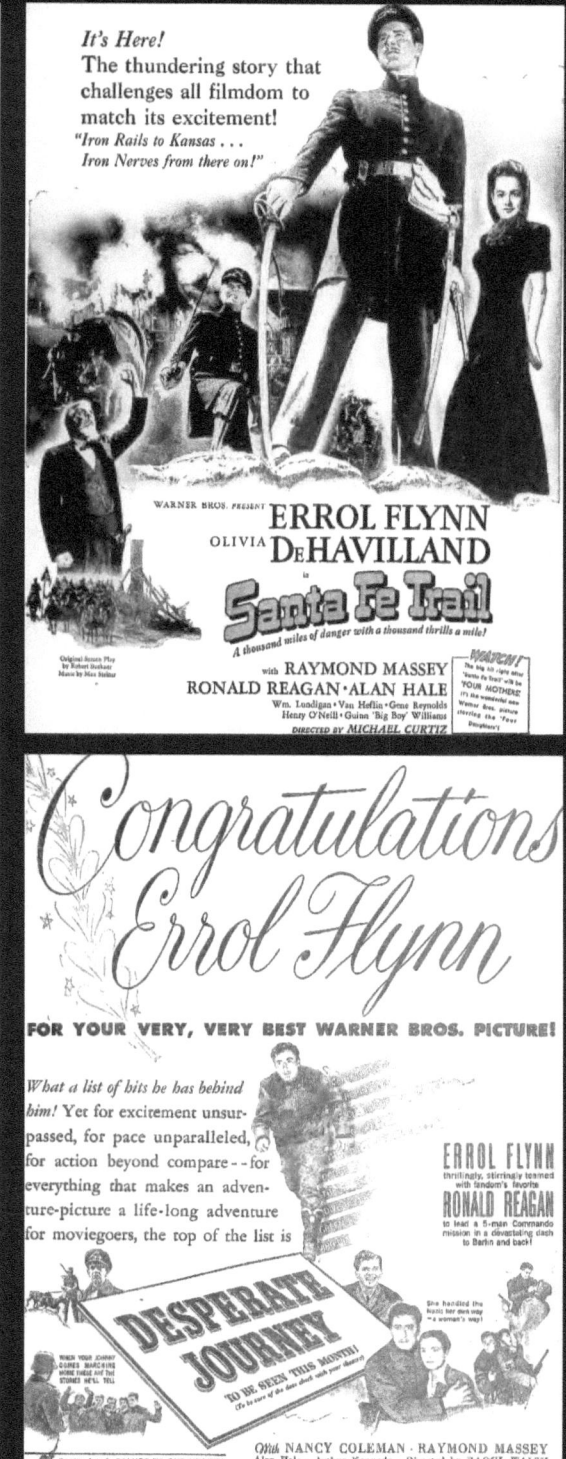

gold-fretted steel corselet and helmet laid aside for the moment, had thrown back his head (he wears in this picture a truly distinguished, small Vandyke beard) and, shaken with suppressed laughter, was holding to the shoulder of Sir Francis Bacon (Donald Crisp) for support. (They had lots of gags about "Crisp Bacon.")

The Queen scooped up her farthingale and petticoat, and went to investigate. When she reached the corner, Olivia de Havilland (she has the role of Lady Penelope Gray, the Queen's rival in the affections of Essex) was peering through a magnifying glass at a tapestry, rich in dim reds and greens, purples and blues, which hung upon the wall of the Throne Room.

"I don't see anything," Olivia said unsuspectingly.

"Here, let me fix the glass," Flynn offered. He touched a spring and Olivia leaped into the air with shock and surprise. A squirt of water had hit her square in the face.

"I might have known!" she said, stamping a foot in pretended wrath, as a makeup man stepped forward with tissue to mop her dry.

"Kid stuff, by my halidome," remarked the Queen, and at once matched it. From somewhere in her voluminous attire she produced Lily. Lily is a mechanical sheep which sings the song about Mary's little lamb. Bette wound up Lily and put her on the floor, to the mingled astonishment and concern of Flynn's huge schnauzer, Arno.

Arno, whom they once found asleep on the $1200 hand carving and $800 velours cushions of the Queen's throne, couldn't abide Lily. But just as, goggle-eyed, he extended a devastating paw. Director Michael Curtiz called out in his Hungarian English: "Everybody get closer together apart, please. We go!"

So the camera crew got closer together apart. Bette sat in her chair of State. Essex knelt at her feet. It was THE love scene.

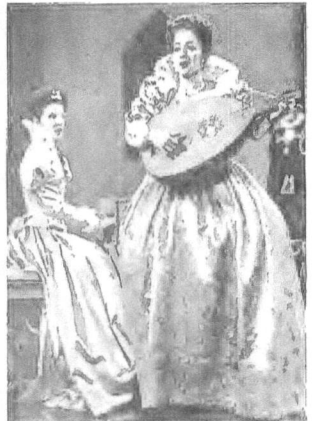

Olivia de Havilland plays Lady Penelope whose beauty and sharp tongue make her a dangerous rival to the aging Queen

Fifteen minutes of it, rehearsed for a week —the key scene of the picture.

Essex, the darling of Elizabeth and of the populace, won glory in the Spanish war but quarreled with the Queen after his return. This was their reconciliation. Not long afterward, he failed as conqueror of the Irish rebels (a fine thing, sending a man named Flynn to fight against the Irish), and hurried back to London to appease Elizabeth. Here he made a fatal error. He raised a company of followers, marched on the palace, and tried to abduct the Queen.

Hurt to the quick by this treason of her lover, Elizabeth imprisoned him in the Tower of London and sentenced him to the block. At the last moment—according to the Maxwell Anderson stage play, "Elizabeth the Queen," from which the film is taken, but not according to history—Elizabeth summoned Essex to a room in the Tower, begged him to marry her. But (again in the film, not in history) Essex chose the block because he knew that, given the chance, he would try to seize the crown for himself, alone. This, briefly, is the story of Elizabeth's tragic romance in her later years.

"We go!" said Curtiz . . . The love scene started well with Essex romantic and melting, Elizabeth tender. Then, in a rush of emotion, the Queen threw her arms about the knight's neck and pulled him toward her. Flynn, upon one knee, lost his balance and completely folded up; simply fell kerplunk across the royal lap. Dignity fled.

The Queen howled. Essex slid to the floor and sat there, chortling. The voice of Curtiz rose above the general mirth: "Bette, I guess you don't know your own strength, isn't it?"

The scene was resumed and this time it went through unmarred to its end; fervent, pathetic, stirring. It is one of the most remarkable and touching love scenes ever put upon celluloid. Elizabeth was ruthless, as perhaps a monarch had to be, but in that sequence Bette leaves you weak with sympathy for a lonely, hard old woman who, in agony of soul, tried to capture the one thing the world had never given her: genuine love.

When the scene was ended, the Queen's Grace nibbled at an ice cream cone with due regard to precious farthingale and stomacher, Lord Burghley (Henry Stephenson) took a swig from a bottle of pop without spilling it down his velvet and brocade doublet. Both watched the prop boys setting up mirrors in the Queen's boudoir. Bette eyed them askance. She's superstitious.

The panelled boudoir and all the other rooms in Whitehall Palace, were reproduced at much cost from drawings made in London. Whitehall as it stands now—Government offices have occupied it these many hundred years—is only a building erected upon the site of the original palace, which was burned in 1689. Recently, however, the British Government excavated the foundations and what is left of the original walls, and the Warners' set was carefully based on authentic data. The dark carved panels, its sombre stone, its arched fireplaces, form a perfect techni-

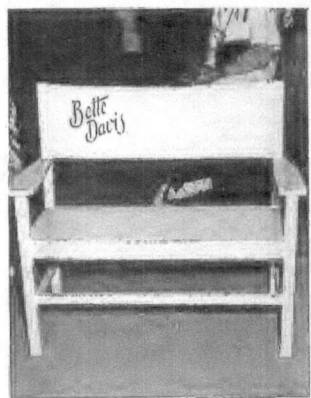

Especially built to accommodate the heavy spreading skirts of Queen Elizabeth's costumes was this chair, used on the set by Bette Davis between scenes

color background for the rich costumes of the court.

The Tudor times were noted for extravagantly beautiful dress. And the Queen led them all. On State occasions she even commanded her maids of honor to wear white so that her own robes would shine forth with the more magnificence.

When Essex gives a little hawking party at his country place in Wanstead, Bette wears a bottle green brocade riding habit with a long green velvet cloak. Once, at the Council table, she wears white quilted satin sewn all over with pearls. For the love scene she has a changeable green and bronze taffeta, with a high, delicate lace ruff. The dress is embroidered in gold and emeralds. A pendant of rubies, diamonds, and pearls is at her throat, pearl drops are in her ears, and on her fingers sparkle five rings of rubies, pearls, diamonds, emeralds, and aquamarines.

As for the men—the Warner's wardrobe department order for a man's costume was usually so many yards of velvet and six pounds of sawdust. It seems the Elizabethans achieved that swank baggy-knee breeches effect by the aid of a lumber yard. Flynn is thoroughly well dressed as Essex. He wears beige suede, black velvet and gold trimmings under his armor in Ireland. Dark green velvet with silver braid, and blue-green brocatelle edged with silver make a Court costume.

■ But Bette's mind was not on the subject of dress at the moment. She was looking at those mirrors, just put up around the royal boudoir wall. "You're sure it's okay to break them if you do it on purpose?" she inquired again.

There had been (some days before, in accordance with the jigsaw Hollywood custom) a savage scene between Elizabeth and Lady Penelope Gray and now Bette was to play the climax of it. Lady Penelope, intrepid wench! had responded surprisingly to the Queen's order to take her lute in hand and sing a song.

Instead of the real verses of "The Passionate Shepherd"—a ballad popular in Elizabeth's day—Penelope sang some verses lately improvised by the Queen's ex-favorite, Raleigh. Far in the past was the chivalrous cloak-and-puddle incident whereby Raleigh had won favor with Elizabeth, and Raleigh was envious of the current power of Essex. His verses, therefore, deftly and subtly twitted the Queen on her fading charms. By contrast, as she sang them, Penelope's fresh loveliness stood out radiantly.

You know Elizabeth's red-headed temper? Only that fortnight, in the throne room, Essex had ventured to contradict her. Smack! Right before the entire Court her hand shot out and caught Essex down the side of the face and the mouth. And this was *Essex*, mind you . . . the man Elizabeth loved.

Accordingly, when Penelope sang the jeering verses, nobody would have been surprised if royal assault and battery, perhaps even the headsman's axe, had resulted. But Elizabeth, woman as well as Queen, realized how the Court would buzz if she dignified the incident by too much notice. She dismissed her ladies with the air of a cobra ready to spring and, when the door closed, walked up to a mirror.

Fading charms! True. With new eyes she studied her drawn features, the wrinkled forehead, the lines around the mouth. And then Elizabeth (despite Bette's superstitions qualms) picked up a vase and crashed it into the glass. Tankards, chairs, whatever weapon came handy, she hurled at the other mirrors in the room. It turned out that Bette's aim was equally bad with either hand. She broke 28 mirrors before she was able to go through the scene and plant a direct hit on each glass in turn.

"Anybody should have a wife couldn't aim any better," Curtiz gaily commented.

■ Alas for those who said breaking mirrors a-purpose didn't c o u n t! Superstition or not, here's what happened. Olivia was laid up 24 hours when she banged her leg against a heavy table. Bette stayed home ten days with laryngitis. And Flynn delayed production a week when an accident required four stitches in his eyelid.

It's a wonder, though, that half the cast didn't come from the picture with web feet, considering the length of time Essex and his men spent in that Irish bog on Stage 11! It was a two and one-half acre bog, complete with trees and hummocks and water and stumps and a thick Irish fog that drifted in whenever Curtiz ordered it. Through this bog, Essex chased Tyrone, the Irish rebel leader (Alan Hale).

Technicolor requires more lights than ordinary film. Thanks to the lights, the temperature on the set, even upon cool days, was (take a deep breath and reach for a fan) 127.

■ But temperature and wet weren't the only things that bothered the English troops and the Irish rebels who played hide and seek among the misty tree trunks. On a Monday the cast assembled in the bog to discover that during the week end it had been taken over by frogs from the adjacent Los Angeles river. The hoarse, delighted croaks (for there was more water on the sound stage than in the river-bed at that season) almost drowned the Curtiz thunderings.

"Get those froggies out!" he shouted, "somebody ribs me, no?"

With nets from the prop department, the cast spent an hilarious hour capturing the froggies and sending them back to the river—by special messenger.

It was while Essex fought rebels and froggies that the Queen fumed because she had no word from him. . . . She did not guess that Raleigh and Lady Penelope intercepted his letters.

But Elizabeth was shrewd and she did suspect the Lady Penelope of trying to attract the notice of Essex. So one evening she and Penelope sat down to a cozy game of chess. The hand carved chess set cost $1,000. When it wasn't in use, they kept it in a fireproof vault at the studio.

Penelope on this occasion wore an inconspicuous little outfit of light blue satin, dripping with lace, a walloping diamond necklace with pearl drops, diamond earrings, and a head ornament plastered with gems. Elizabeth, also quietly garbed for an evening at home, wore a gold and green slashed gown weighted with perhaps a couple of quarts of diamonds, pearls, emeralds, rubies and sapphires. And a jewelled ostrich fan of red.

Well, in this chess game Elizabeth had the black knight (you play chess with queens, knights, castles and whatnot, remember?) and she said nastily: "So you would take the queen's knight, Mistress Penelope?"

"All knights are fair game, Your Grace," Penelope replied smartly.

"But," said Elizabeth, "the queen will protect her own—" and when Penelope was about to win, she swept all the chessmen to the floor!

Yet both women eventually lost the proud, head-strong Essex. Nobody who hears the Queen's voice in that final scene is likely to forget it. A few minutes before his execution, Essex refused his life at Elizabeth's hands, refused even her frantic offer to share the throne with him.

"No, Elizabeth: I'm over-ambitious—I'd be your death. And you, and England, must live." He turned toward the door; the massive portal of the royal suite in the Tower of London.

"Robert!" Elizabeth screamed, "take all! Take my crown! Take England!"

But Essex was gone. Presently from the courtyard rose the roll of drums, louder and louder. Then silence.

The stunned heartbreak on Elizabeth's face changed to mock indignation as Bette and Flynn left the set a moment later. Grinning, Flynn said something. Bette suddenly clutched her weighty skirts so that she could walk faster after him while Flynn hastened his stride to keep one step ahead of whatever reprisal she contemplated.

"I only said," Flynn broadcast with injured innocence, " 'Bette, if you could see how you don't look like yourself in that make-up, you wouldn't blame the guy for saying he'd rather die than marry you!' "

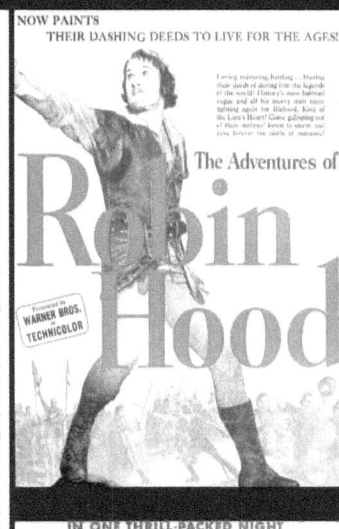

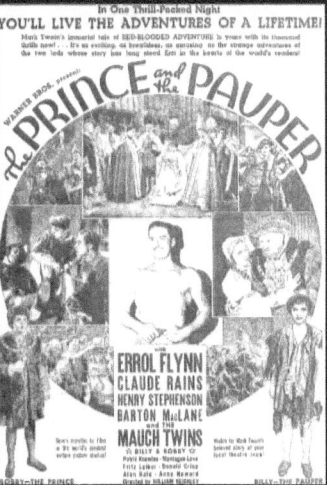

The Sea Hawk

They built an ocean and two full-rigged ships for a production that had plenty of excitement during the filming as well as on the screen

By JESSIE HENDERSON

Flora Robson once more plays Good Queen Bess. Here she is in one of her magnificent costumes knitting a British War Relief sweater

There is plenty of fast action when Errol Flynn fights his way through the corridors of the palace against his enemies in the Queen's own guard

Errol Flynn, as the gallant captain, during the evil days of his capture by the enemy serves his time at the sweeps deep in the hold of the ship

Brenda Marshall had her troubles with "Professor," the acting monkey, when they had a difference of ideas about her gros point chair covering

■ Slowly the great ship rolled, beneath a cloud of canvas, through a smother of angry foam. Then, with a majestic swoop, it curtseyed till the horizon reeled and the toughest Elizabethan sailor aboard said, "Gosh!" And gulped uneasily. Half of the sixteenth century buckaroos were seasick the first day.

As a matter of fact, the only two privateers who didn't grow queasy once in the course of the voyage were Errol Flynn and Alan Hale. They sail boats, themselves. But not across oceans like this.

For all that deep sea stuff was proceeding merrily upon an indoors ocean with a roof over it. A life on the rolling wave, with plenty of wave, had been concocted at the Warner studio inside the world's largest sound stage. The billows heaved exclusively and expensively on behalf of The Sea Hawk, that romantic tale of derring-do in the England of 1585. And where the indoor briny had it over the outdoor kind—they could turn off the weather whenever Director Mike Curtiz told them to cut out the mechanism.

He told them. The roll stopped. In a jiffy, or as soon as the camera could be set up at a new angle, the ship came quietly to dock in the English harbor of Dover. Boy, what a trip! And there on the high, carved quarterdeck stood the hero of it.

He was Francis Thorpe, played by Errol Flynn, a gallant figure in green and russet velvet, with a sword that glittered in the sun and a cape that flung out jauntily at each impatient gesture. He was impatient for the sight of a pair of dark Spanish eyes . . . for little Maria, proud and alien among the ladies of the English court. . . .

Meanwhile, on the roofs and quays the whole town crowded, roaring with excitement. It waited the arrival of Good Queen Bess (Flora Robson) who was coming to reward young Thorpe with knighthood.

The character of Francis Thorpe was patterned after that of Admiral Sir Francis Drake. It's worthy of note in passing that Drake cruised along the California coast only twenty miles and four hundred years from the spot where Warner's were now filming exploits based upon his.

Like Drake, the gentleman-adventurer of The Sea Hawk had plagued the treasure ship of King Philip of Spain, England's bitter enemy, from South America to the Bay of Cadiz. He stood ready this moment at the drop of a hat—one of those curly-plumed, swashbuckling hats in which Errol looks so well—to sail against Philip's armada which was heading toward the English shore. He paused only for the Queen's godspeed.

A sudden hush gripped the throng of townspeople. The hush was followed by a shout of welcome, and a shuffle to make room before the levelled pikes and glinting breastplates of the guard.

The Queen! She moved majestic as a galleon herself, resplendent in gold and emerald brocade, and behind her came the shining wake of gentlemen in rich purples and tawnies and blues, the maids of honor in wide farthingales and jewelled stomachers. Among the court guests, in a gown of garnet silk, came Maria (Brenda Marshall), whose lips had once hardened with scorn for the English "buccaneer," but whose Castilian heart and pride had melted fast enough when Thorpe made love to her.

On shipboard a crimson canopy had been stretched above the chair of State to which they escorted the Queen. The royal group blazed

The Sea Hawk

with color against a background of ropes and spars, green harbor water, and the quaint old eaves of Dover town. Thorpe approached the carpeted dais where he must kneel to receive the sword tap that would give him the title "Sir." Cameras turned, onlookers held their breath at the gorgeous spectacle . . .

And in that solemn moment Alan Hale tripped over Errol's sword, fell down boom, and slid across the resined deck on his tummy.

He stopped the show. "Ooops!" cried the Queen. And Flynn folded up on the dais step and howled.

Still, as it turned out, Alan wasn't by any means the only one who took a tumble before the production ended. Most of the others, however, fell into the "ocean"; intentionally or otherwise.

The studio built two full-sized sixteenth century craft on the enormous stage, and a brave sight they were with their painted armorials and gilded prows. One, of course, was Errol's; the second, the Madre di Dios, was his antagonist's. Into the two boats went enough lumber to build 250 four-room cottages. Each was about 180 feet over all, and together they cost $150,000 of the million and a half spent on the film.

Altogether, they merited the "lunching" held for them at a studio party where seven girls from seven lands gave Errol seven vials filled from the seven seas, to break on the bows of the vessels. The place was so full of pretty damsels that the name of the picture could well have been changed to "The Chicken Hawk."

The craft were practical, too, not merely for looks. Before certain sequences the stage was flooded to a considerable depth and the ships could actually sail for forty feet into a scene. Which, on a sound stage, is some feat.

But to get back to those people who fell into the "ocean," and did it so often that the production was dubbed "Webfooted" among its friends. The rival ships met in a whale of a battle when Errol captured the vessel on which were Maria and her uncle, the Spanish Ambassador to London. As is usual with the movies, the fight lasted for days, and the rival crews developed a humorous feud. Between takes they leaned from their adjacent riggings and sent one another kersplash. All in the interests of good, clean fun.

In the thick of this battle, while steel clashed and cannon thundered, Errol made a daring leap from his own deck to that of the enemy. Sword in hand, he fought his way to the hold to free the English prisoners chained as galley slaves. Then he raced to the upper deck to join in the fray again.

Here his attention was attracted by the leaded amber windows of an officer's cabin. He thrust open the door and stood amazed at the magnificence of the furnishings. The rare old pewter and silver, table and chairs in this scene, by the way, were insured for nearly $100,000. He saw a table set for dinner, the heavy silver platters and goblets twinkling in the light of candles burning in gold candlesticks.

And here he caught his first sight of Maria. Her yellow gown with its fine white ruff was in strong contrast with the dark panels of the wall against which she leaned. Maria was terrified, but defiant. He swept her a bow, with a grin of pure deviltry for her expression of an embattled kitten. Maria acknowledged this amenity with a look that said she'd like to kill him, and would try to, the instant an opportunity offered.

"Pirate!" she remarked.

He didn't, on the whole, make a good impression at this first meeting. But Maria did!

■ Long before noon on the first day's shooting of that sea fight, the combatants were half smothered by the smoke of their own cannon, and half starved after all the violent exercise. Came the lunch hour, but Director Curtiz made no move toward the commissary until Errol as a reminder adroitly slid a menu under the directorial arm.

It worked. But to safeguard the future, Errol conferred with an electrician. Next day on the stroke of twelve, in the middle of a dignified scene on the Madre di Dios with Spanish Ambassador Claude Rains . . . BONG-NG-NG-NG!! Curtiz nearly jumped overboard. The electrician had rigged up an alarm clock to the ship's bell. They ate on time that day, no foolin'.

But the scenario had things in store for Errol which made a delayed meal insignificant. Trouble followed him like a camera boom, for, as everybody is aware, in the life of a cinema hero the disasters come fast and plentiful as close-ups. First thing you knew, Thorpe was off to Panama to intercept King Philip's treasure caravan as it toiled across the Isthmus. And such was the web of treachery spun about Elizabeth's court by Philip's agents, that Thorpe suspected even Maria—and left in secret. He didn't receive her warning that the Spaniards knew of his plans.

■ For the Panama jungle scene, they assembled over 200 kinds of South American trees and shrubs and vines— $10,000 worth—on a foundation of ditches and water pipes. There were eight acres of it. The moist heat, the scent of leaves and flowers, were overpowering. It was

an area of dark, forbidding beauty.

Through this tangled maze crept Thorpe and his men, ready to pounce on the mule-drawn treasure wagons—w h i l e King Philip in faraway Spain chuckled over the counter-ambush his spies had engineered. Montagu Love, in the role of Philip, was ruling his twelfth kingdom. During the past thirty years he has played twelve kings, eight princes, five dukes, and three dictators. He holds the celluloid record for jobs of the sort.

Philip proved too crafty for Thorpe. A prisoner, the Englishman was brought back to Spain, but in a hairbreadth escape he reached London and met Maria—of all people—riding in a coach . . . Errol Flynn had been through a lot in the jungle and on the prison ship—but Brenda Marshall as Maria suffered more when she had to propose to him and make her offer good with a kiss.

■ Brenda—herself brought up romantically on her father's sugar plantation in the Philippines—had played only one important role previously on the screen. She had never kissed a man in front of the camera. And for the first one to be the famous Errol Flynn—! While she waited for the coach scene, she tried to conceal her nervousness. But Errol noticed the trembling hands.

"I believe you're the second shyest person in Hollywood," he said gently, "I'm the first . . . But don't be frightened, Brenda. Remember, I'm more scared of this scene than you are!"

That made her laugh. They climbed into the ornate coach. "I love you!" Maria said to Francis Thorpe without nervousness. She leaned forward, hesitated an instant, and kissed him on the lips—fervently. The very first take was okay.

■ Not so the first take of another scene they shared! Curtiz, whose wild Hungarian accent is a constant delight and puzzle, wanted a fanfare of trumpets to announce the entrance of Brenda and Errol at a certain point. He was understood to order it played "good and hot!" The trumpeters, surprised but obedient, played it good and hot; and before Curtiz recovered from his stupefaction, Brenda and Errol, getting into the spirit of the thing, entered with knees prancing, heads bobbing and fingers waggling, like a pair of snazzy jitterbugs.

Gilbert Roland (the Spanish Captain Lopez), Donald Crisp (Sir John Burleson) and Una O'Connor (Maria's duenna), broke into spontaneous applause from the sidelines. But it seems what Curtiz had said was "good and hard."

■ Despite these lighter moments, trouble continued to dog the hero. Hardly had he made good and returned to the comparative safety of London than he met traitorous Lord Wolfingham (Henry Daniell) in a corridor of Elizabeth's palace—and was *that* a duel! It lasted eight hours.

The duel took place on one of the finest sets of the picture—a truly splendid corridor flanked by sixty-foot columns. Between "takes" of the sword play, a man with a vacuum cleaner went over the vast red and orange rug before Elizabeth's throne (imagine!) which could be seen through an open door. Somebody else dusted the precious antiques.

Yet what came in for the most exquisite care were not antiques, but the six hundred giant candles, of no remarkable value, which lighted the corridor. Sixteen men tended them. To preserve the candles in their half burned condition, they were checked and numbered and registered in a ledger before being placed tenderly one by one in slots provided in a cabinet. The cabinet was then locked by the head prop man, who put the key in a studio safe!

You see, there were to be additional scenes in the corridor with Maria and the Queen hurrying in as the duel ended. But the additional scenes were not to be shot until the following week. So Curtiz wanted the candles to match exactly.

While they were checking up on the candles, somebody else, who was checking up on other things, discovered Claude Rains pampering his pet superstition. For this, Curtiz presented him with the rubber booby, a medal given to anyone who pulls a boner on the set. The recipient keeps it till a fellow player pulls a worse one.

Claude got the rubber booby for wearing his Spanish Ambassador trunks wrong side out. On purpose. He says it's lucky. And, right side or wrong, he didn't like the trunks. "These Elizabethan rompers!" he complained, "they don't even have a pocket to keep a rabbit's foot in!"

■ It wasn't long before the rest of the cast began to think that a rabbit's foot, and a big one, might be a darn good idea for each of them. Players in the jungle sequence had congratulated themselves at its end that no scene could be more arduous and hot and sticky. Whew! But a more arduous scene, more hot and more sticky, lay ahead.

On a morning when the mercury touched 91°, the principals of the cast had to climb into their sweltering sixteenth century duds and devour a feast of roast mutton and capon, veal and beef, coney and salted fish.

And—this is the pay-off—they had to devour it not only with their fingers, but with every sign of keen enjoyment and appetite, all the morning from eight o'clock on. Had to devour it *three times* . . .

They! Hollywood players, whose faces are their fortunes, whose figures are their careers, and whose ordinary breakfast is a sip of black coffee and a prayer that their hips will stay "down"!

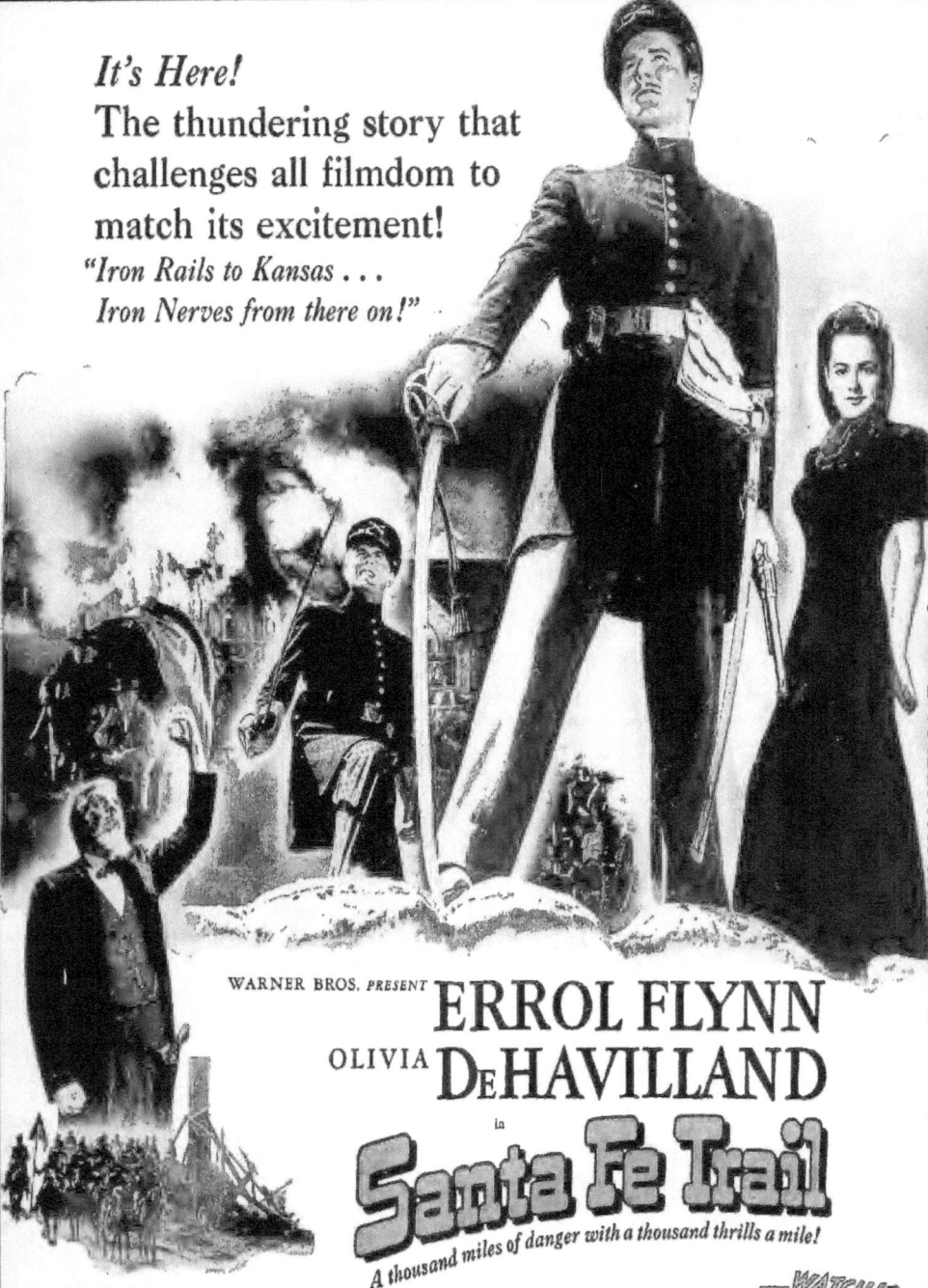

Is Errol Flynn Bored With Life?

Errol Flynn plays a humorous sleuthing role in Warners' *Footsteps in the Dark*.

By VIRGINIA WOOD

Not long ago, Errol Flynn was invited to Palm Springs to one of Rex St. Cyr's dinner parties. The dinner was on a Saturday night and the guests had been invited for the week-end. Sunday was a dreary day—stormy and cloudy. One of the big American Airliners had been grounded at Palm Springs and the passengers were sent to town by automobile. Errol drifted over, got to chatting with the pilot.

"Well, it's back to Dallas for me," the pilot said, wearily, explaining that weather conditions to the South were okay and he'd been ordered to bring his plane back.

Inside of an hour, Errol had bought a ticket and was on his way to Dallas—the lone passenger. It seemed like a good idea at the time. He had no idea where he'd wind up.

Monday he made a pleasantly surprised landing in New York. Tuesday wasn't so good, however. The weather was cold and Errol was equipped with only his Palm Springs clothes.

So he spent Christmas day in bed getting rid of a bad cold.

Back in Hollywood a few days later, he found he just had time to make the Clipper ship, which was leaving for Honolulu. You see, his boat, the Sirocco, had already sailed and Errol had been supposed to meet the gang, but, as usual, was late and, again—it just seemed like a good idea—so why not?

The thing Errol loathes most in life is boredom.

A plane trip, to Errol, is so routine as to be dull. It merely represents a period of time to be endured until action starts again—until he can move.

He tells an amusing story that happened last year when he went to Honolulu. Naturally, he spent his last waking hours catching up with all the sights in the town and was exhausted when he boarded the plane. Havng procured a sleeping powder from the steward, he settled down in his berth to sleep until he arrived on the Mainland.

Upon being awakened by the steward he muttered something about getting in touch with his chauffeur who was waiting to drive him back to Hollywood.

"But we're not in the United States," the steward informed him brightly. "We got a thousand miles out and had to swing in again. We're back in Honolulu!"

Errol grinned contentedly and promptly settled down to three more days of waiting until the ship could take off. He thoroughly enjoyed sending a wire to the studio, quoting the "Act of God" clause in his contract!

Everything Errol does he does violently. When he plays tennis, he stays on the court until exhausted. When deep sea fishing, he's indefatigable. And everything he learns, he learns thoroughly.

A few years ago, he had his first real taste of deep sea sport fishing on Cat Cay, in the Bahamas. From that time on, Errol has been an addict. He was heart-broken because he had to come back to Hollywood without catching a record breaker. He couldn't wait to get back. In fact, he didn't. His old boat, the Cheerio, was anchored off Coronado. Every free minute, Errol spent on board, rigging it up with new tackle, reels and gadgets—getting it in shape for a marlin run. His only ambition was to catch THE fish.

When summer came, Errol bought himself a plane and flew back to Cat Cay. He was admitted to the Cat Cay Tuna Tournament—the only theatrical member among such people as Walter Chrysler, Jr., Alfred P. Sloan, Edsel Ford, etc.

And his dream came true, as it always does. He caught the record tuna—weight 564 lbs.

Errol has a keen sense of the ridiculous and does his best "hamming" between scenes on the set. There was a scene in *Santa Fe Trail*, for instance, that struck him as being pretty silly. He felt foolish carrying his sword with a small handkerchief waving at the end—a flag of truce. He had the whole crew in hysterics as he exaggerated the action during rehearsal shots, much to the disgust of Mike Curtiz, the director. Mike and Errol are great friends, however, and Mike finally broke down like the rest of the crew. Errol, of course, takes special delight in annoying Mike because of his famous tirades in broken English. And Mike loves it.

Oddly enough, strangers scare him to death. He becomes extremely self-conscious when being introduced to strangers and for that reason often seems rude, in that he will suddenly break away with a muttered excuse and shut himself up in his dressing room. If he knows about it beforehand, however, and feels that he might have something in common with the newcomer, he will yarn for hours.

Recently, when a delegation from South America was entertained on the set and at luncheon in the studio, Errol became so engrossed in conversation he was an hour and a half late getting back to the set. This was because he was, and is, intensely interested in the Pan-American situation and felt that he had something to contribute to the conversation. All the King's horses, however, coudn't drag him into a discussion for which he held no interest— or in which he'd been told he really should be interested.

He's extremely slow to make friends, although his studio dressing room is constantly overflowing with the ones that he has. Bud Ernst and Johnny Meyer are among his closest friends and they are constantly with him.

When he finds himself getting bored with people or their conversation, he often ducks into the dressing room on some dreamt-up excuse to write. He has a great ambition to one day really do something with this talent—when he can afford to take the time off to do it. Meantime, he just dabbles. He always, however, has a story he's working on.

In *Footsteps in the Dark*, he decided to bring back bow ties, which haven't been too popular for a long time. There was much argument about this. The director didn't approve. No one approved, but Errol was firm. In the finished film, he looked so well the studio people are convinced he really started something. It probably all started because Errol was bored and just felt in the mood for an argument!

END

Their eighth picture together! That's the score at present for Olivia de Havilland and Errol Flynn, who are sweethearts again in *They Died With Their Boots On*, Warners' historical drama of Custer's Last Stand. It's all in Technicolor, too

Heap Big Romance

By TOM DeVANE

The Hollywood Indians were good and mad. They had been told for months about the new Warner Brothers historical epic, *They Died With Their Boots On*, which boasts Errol Flynn and Olivia de Havilland as stars, and Custer's Last Stand, in full and gory Technicolor, as the *pièce de resistance*.

Now Custer's Last Stand, as any school child knows, means Indians, and the Hollywood red men felt assured of weeks of steady employment, massacring *General Custer* and his brave men.

Then out of a bright blue sky came the blow: Warner Brothers announced that they were importing some 50 strapping Sioux Indians, right off the Rosebud Reservation in South Dakota, to show dashing Errol and his soldiers a bad time. The horrid explanation given by studio officials was that the Hollywood Indians were either too old or too fat—and the imported Sioux were all prime specimens of vigorous manhood.

This was an insult. There was even some talk among the movie redskins about scalping a few Warner executives, as a mild protest. But since neither producer Jack Warner nor director Mike Curtiz are good scalping material, they didn't worry. And even grinned when the Hollywood Indians began to picket, on a prominent corner. In full warpaint, in front of a huge teepee, they began to pace up and down, bearing huge signs reading "Warner Brothers Unfair to Hollywood Indians!"

But out at Calabasas, California, a wild stretch of country that looks more like the Black Hills than they do, there was more dissatisfaction. The Sioux visitors weren't happy men. The studio had generously built them a fine barracks, much more elaborate than their own home quarters, and there the poor Indians had to stay unless actually working on the picture. The Department of Interior, which had lent its wards to the movie makers, had insisted that there be no night life for the new actors.

The Hollywood Indians gloated among themselves when they heard this. They, at least, were free to roam the brightly-lighted streets of the film town, and even buy a few beers for themselves, pleasures denied their South Dakota cousins.

Warners is going to great lengths to make *They Died With Their Boots On* as authentic as possible. When we cantered out to Burbank the other day, having been assured that the company was on the lot, we learned a great deal about the brave *General Custer*. The whole company of *T. D. W. T. B. O.* is steeped in the *Custer* legend.

Our first shock was in learning that *General Custer*, idol of millions these many years, was the worst student ever graduated from West Point Military Academy. He broke every rule and disobeyed orders when he felt like it. Just before graduation, he had 99 demerits against him—and 100 meant dismissal. On graduation day *Custer* was in the guardhouse—so his diploma was turned over to him by the turnkey as he left. West Point was glad to see him go.

This was in 1861, and *Custer* was commissioned a Second Lieutenant. But two years later he was known as a Brigadier General (much to the bewilderment of the War Department, who hadn't made him one!) and fighting on the side of the North in the Civil War, leading his own company, then known as the Michigan Brigade. *Custer* became a great popular hero in the Civil War, because of his daring, often foolhardy, exploits. And also because of his rugged good looks and his spectacular uniforms, which he designed himself.

After the War, *Custer* was retired as a

Captain on a mere pension—but he didn't take that sitting down. He howled and bellowed so loudly that the War Department nervously gave him command of the 7th Cavalry, in Indian Territory, in 1866. This was the same 7th Cavalry that was to die, along with their general, with their boots on.

Not a few Warner Brothers people commented on the similarity between dashing *General Custer* and dashing Errol Flynn. "Guess Flynn's got a part that really suits him this time," they observed, remembering the rebellious antics that have made the star one of Hollywood's most colorful figures these past six or seven years.

Flynn seems happy about it, too—though he might not have been had they followed the original plans and made him play *Custer* with moustache and beard and long shoulder-length black hair.

But sometimes authenticity can go too far. Flynn agreed to make the required tests with long curly wigs. And he was at the studio bright and early next day to see the rushes. As the tests were flashed upon the screen, everyone waited for Flynn to explode. He didn't. He merely made a wry face and said, "Migawd, I look like Shirley Temple!"

So the long wig was out. The new Flynn hair-do is a modified page-boy effect—and in order to keep it looking nice, the studio gave him Bette Davis' hairdresser!

Flynn has long been known as the most insouciant star in Hollywood, but he dropped the indifferent mask early in the filming of *They Died With Their Boots On*. They say he cried when the body of his beloved Schnauser, Arno, was recovered on the coast off Balboa Bay. The big dog had been swept overboard at night, and wasn't missed for hours. Flynn hoped against hope that Arno had managed to reach shore, because he had been washed overboard before. But no dog will ever take Arno's place.

Both Errol and Olivia de Havilland were working when we arrived on the set—Flynn very handsome in his cadet's uniform, and Olivia lovely in full-skirted period costume. It was, we discovered, their first scene together in the picture, with the brash Olivia trying to scrape up an acquaintance with the young cadet. She keeps up a rapid fire of conversation as he paces up and down in front of her, musket on shoulder, never answering a word, or giving her a glance. Olivia doesn't know that he is on guard duty, and therefore not allowed to talk.

"I've never been to West Point before," she volunteers archly, "and it's even more wonderful than I thought it would be!"

No answer from Flynn.

"It's thrilling to see all the wonderful places I had heard about—like Flirtation Walk—"

Flynn continues his relentless marching up and down in front of the bench on which she is seated. It is obvious that he would like to become friendly—but other cadets are spying on him to try to catch him breaking a rule. Olivia babbles on for a while, but finally tosses her head and leaves, with a flounce of her hoopskirts. (The next scene, however, has her telling her father that she has just met the man she is going to marry.)

Warner historians proudly point out that while *They Died With Their Boots On* is the eighth co-starring picture for the famous team of Flynn and de Havilland, they have never played man and wife before. Said Olivia, when we got a chance to chat with her: "I only hope the real life *General and Mrs. Custer* were half as romantic as Flynn and I are in this picture! History tells us that they were actually an extremely devoted couple."

Olivia had just returned from a wonderful vacation in Cape Cod, Massachusetts. "I was so tired and exhausted after I finished *Hold Back the Dawn* at Paramount that I just hopped a plane, without letting anyone but my mother know where I was going. I found a lovely old hotel and settled down to relax. No one knew, or cared, who I was. But my, how they buzzed when Lew Ayres tracked me down after a few days. Mother hadn't given him my address when he found that he had to make a sudden trip East. Lew had a rented car, and wanted to tour the cape from one end to the other.

"And we did. I told Lew how wonderful it was to be unrecognized, and how I was enjoying my vacation. But every place we went, they recognized *him*. Whispers of '*Dr. Kildare!*' went up every time we stopped to do a bit of sight-seeing. I didn't mind for the first couple of hours, then I began to burn around the edges. No one even *looked* at me! The final blow came when we got back to Boston, where I had gone to see Lew off at the airport. Of all the reporters and photographers there, not even one recognized me. They photographed and interviewed Lew like crazy, while I stood on the sidelines.

"Do you suppose—" mused Olivia, with a twinkle, "that Lew was having a bit of fun at my expense? That's what I got for boasting of the joys of being unrecognized. I realized that I didn't like it *at all!* De Havilland, the ham."

They Died With Their Boots On has quite a lot of plot, most of it authentic. There's a sub-plot, strictly Warner Brothers, that has *General Custer* feuding with a fictitious character named *Sharp* (Arthur Kennedy) who runs a trading post and sells whiskey and guns to the redskins. This is considered quite naughty business, as is *Sharp's* inducing settlers to come out and settle in Indian Territory, a sure fire invitation to scalping. And there's a big supporting cast: Stanley Ridges, Walter Hampden, John Litel, Gene Lockhart, Anthony Quinn and Regis Toomey—picture stealers all. ■

Hattie McDaniel, who has an *Oscar* to her credit, has another of the *Mammy* roles she does so well

Anthony Quinn gets away from the gangster roles which are his usual lot to portray *Crazy Horse*

Real Sioux Indians were brought from North Dakota for the film. None had ever been off their reservation before, and found life in Hollywood fascinating. All boast colorful names such as Harry Chin, Flying Cloud, Prairie Dog, etc. They prefer hotel floor to chairs

Congratulations Errol Flynn

FOR YOUR VERY, VERY BEST WARNER BROS. PICTURE!

What a list of hits he has behind him! Yet for excitement unsurpassed, for pace unparalleled, for action beyond compare -- for everything that makes an adventure-picture a life-long adventure for moviegoers, the top of the list is

ERROL FLYNN thrillingly, stirringly teamed with fandom's favorite **RONALD REAGAN** to lead a 5-man Commando mission in a devastating dash to Berlin and back!

DESPERATE JOURNEY

TO BE SEEN THIS MONTH!
(To be sure of the date check with your theatre)

She handled the Nazis her own way — a woman's way!

WHEN YOUR JOHNNY COMES MARCHING HOME THESE ARE THE STORIES HE'LL TELL

With NANCY COLEMAN · RAYMOND MASSEY
Alan Hale · Arthur Kennedy · Directed by RAOUL WALSH
Original Screen Play by Arthur T. Horman
PRODUCED BY HAL B. WALLIS
Music by Max Steiner

September is SALUTE TO OUR HEROES month at all movie theatres! Buy a War Bond to honor every mother's son in Service!

Bibliographic sources :

Hollywood (1934-1943)
Publisher: Hollywood Magazine, inc. ; Fawcett Publications, inc.

Copyright©2012-2014 Iacob Adrian.All Rights Reserved.

This documentary study use,
combined in various proportions,
elements from the following categories,
forms and subsets :
- fair use
- documentary
- documentary photography
- feature
- journalism
- arts journalism
- visual journalism
- photojournalism
- celebrity photography
in order to :
- employ material as the object of cultural critique ,
- quote to illustrate an argument or point ,
- use material in historical sequence,
providing independent opinion,
using photos, press articles, advertisements,
opinions of fans etc. ...

Copyright©2012-2014 Iacob Adrian.All Rights Reserved.

www.ingramcontent.com/pod-product-compliance
Lightning Source LLC
Chambersburg PA
CBHW020948180526
45163CB00006B/2365